VICTORIAN DELIGHTS

𝔙ictorian

DELIGHTS

REFLECTIONS OF TASTE
IN THE NINETEENTH
CENTURY

JOHN HADFIELD

NEW AMSTERDAM
New York

First published in Great Britain 1987 by
The Herbert Press Ltd.

Published in the United States of America by
New Amsterdam Books
171 Madison Avenue
New York, NY 10016

Printed and bound in Hong Kong by
South China Printing Co.
ISBN 0-941533-02-6

FOREWORD

VICTORIANA, AND THE MANY MINOR ARTS which that portmanteau word covers, are subjects which cannot adequately be assessed by a single author. In this book all I have attempted to do is to select a few nineteenth-century arts and artifacts, some of which are perhaps underestimated, and indicate, with the aid of illustrations, their beauty and interest. In so doing I have been greatly indebted to specialist critics who have written on these subjects at greater length and with more authority than I can command.

For arousing my general interest in the byways of nineteenth-century art I owe much to the writings of, and my friendship with, Olive Cook and Edwin Smith, John and Griselda Lewis, James Laver and Sir John Betjeman.

For information and guidance on specific subjects I am greatly indebted to Doris Langley Moore, founder of the Museum of Costume at Bath, for her monograph on *Fashion through Fashion Plates* (Ward Lock, 1971); to Vyvyan Holland's *Hand Coloured Fashion Plates* (Batsford, 1955); to Thomas Balston's *Staffordshire Portrait Figures of the Victorian Age* (Faber, 1958); to *A Collector's History of English Pottery* by Griselda Lewis (Antique Collectors' Club, 1985); to Sir Sacheverell Sitwell's *Morning, Noon and Night in London* (Macmillan, 1948); to *Victorian Music Covers* by Doreen and Sidney Spellman (Evelyn, Adams and Mackay, 1969); to *The Heyday of Natural History* by Lynn Barber (Cape, 1980); to *A History of Valentines* by Ruth Webb Lee (Batsford, 1953) and *The Valentine and its Origins* by Frank Staff (Lutterworth Press, 1969); to *Printed Ephemera* by John Lewis – who introduced that term into the English Language – (W.S. Cowell, 1962); and to *The History of the English Toy Theatre* by George Speaight (Studio Vista, 1969).

It is unfortunate for amateurs who share my interests that most of the essential books of reference mentioned above are now out-of-print, and that some of the most interesting minor artists and craftsmen have not yet been considered worthy of proper critical attention.

I want to thank Peter Scully for providing information about the early history of cigarette cards and for allowing me to illustrate rare cards from his collection, also for persuading his friend Mr Wharton-Tigar to let me illustrate a great rarity in *his* collection. I am grateful, too, for the loan of fashion plates by Mrs Langley Moore and Mrs Edwin Smith, of toy theatre prints by George Speaight, and of early American cabinet photographs by Philip Kaplan. I give thanks for permission to reproduce Valentine cards from the Jonathan King Collection in the Museum of London, several American samplers by courtesy of Sheila and Edwin Rideout, other samplers from the Welsh Folk Museum and Messrs Christie, an outstanding Edward Lear bird print by courtesy of Messrs Sotheby, engravings of livestock from the remarkable library of the Rothamsted Experimental Station, Staffordshire portrait figures from the Balston Collection at Bantock House Museum, by courtesy of the National Trust, and studio pottery in the collections of Miss Priscilla Greville and of Edmund Penning-Rowsell.

I wish to thank my cousin-in-law, Paul Mellon, for helping to open my eyes to the interest of British animal paintings.

I am also grateful for the personal help given me by A. Lloyd Hughes at the Welsh Folk Museum; Yvonne Jones at the Bantock House Museum, Wolverhampton; Nicola Johnson at the Museum of London; Lance Cooper, Derrick Witty and John Lewis who took many photographs especially for the book; John Roberts, who helped with its design; and Gillian Barrett, who transformed my heavily-revised manuscript into faultless typescript.

J. H.

CONTENTS

INTRODUCTION

IMAGINE that many of my contemporaries, born before or during the First World War, have shared my changing view of Victorian taste. In my case it has been a slow process. I was brought up in a neo-gothic mansion built for my great-grandfather in the eighteen-seventies. Its only distinction was a tall central tower, reached by four flights of stairs, from which in 1913 I watched a race between two noted aeronauts, Hux and Hamel, each pilot sitting on the lower wing of his biplane, his legs dangling – or so it seemed – in the air.

My great-grandfather was in most respects a typical Victorian man of business. He had a coach, five servants, and two gardeners. His house was furnished with cumbrous over-ornamented mahogany furniture; and almost every wall was hung with contemporary oil-paintings of negligible merit, in vast gold frames. Yet he was not a philistine. He was acquainted with the Wedgwood family, and every Christmas we dined off a vast and beautiful Wedgwood dinner service. His son, my grandfather, was prominent in local musical activities, and Edward Elgar had stayed in our house for the first performance of *The Dream of Gerontius* in the Birmingham Town Hall.

My mother, however, like so many Edwardians, reacted against Victorian taste, apart from her passionate interest in the Pre-Raphaelites. She spent much of my childhood throwing out the bulkier pieces of Victorian furniture and asking the dustman to dispose of them. Not surprisingly, I grew up to regard 'Victorian' as a pejorative word.

After my mother's death, the family home was demolished, but I saved from it one relic of my great-grandfather – a pair of Walton pottery groups of 'Flight to Egypt' and 'Return from Egypt', one of which is illustrated in this book on page 59. My great-grandfather had acquired them in the eighteen-forties. I have recently bequeathed the pair to my younger grandson.

It took me some years to rid myself of my prejudice against Victoriana. Today I still regard much Victorian architecture and furniture as lacking the innate sense of proportion and design that the Georgian architects and craftsmen possessed. But I began gradually to feel a certain nostalgia for my Victorian roots. Like so many, I found myself sharing the outlook of John Betjeman. And when I took over the editorship of *The Saturday Book* in 1952 two of my contributors, Edwin Smith and Olive Cook, continued to open my eyes to the interest of minor Victorian artifacts and folk art.

I had for long been interested in early Victorian pottery – hence my pleasure in retaining the Walton groups – and as I grew older I realised what a vast amount of 'folk art' had been produced, not only by potters, but by little-known practitioners of a number of minor arts, throughout the nineteenth century. Everyone seemed to know about Chippendale, Hepplewhite, Robert Adam, Wedgwood and other household names of the Georgian and Regency periods. But very few people, other than specialists, knew such names as those of John Walton, Ralph Salt, Obadiah Sherratt, Jules David, Alfred Concanen, John Brandard or the Martin Brothers.

I still have reservations about much Victorian architecture. Apart from masterpieces like St Pancras railway station in London, Burges's Cardiff Castle, St Augustine's Church in Kilburn, and some delightful architectural eccentricities in the United States such as those at Galveston in Texas and in New Orleans, the average mid-Victorian builder laid a heavy hand on most urban districts.

Yet the minor arts of the nineteenth century, the products for the most part

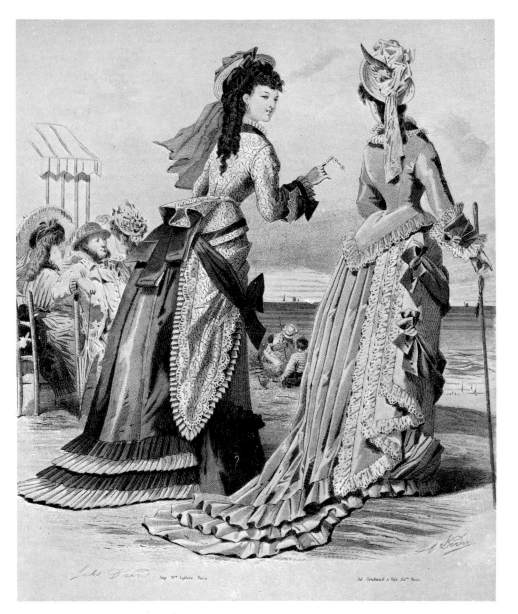

Fashion Plate by Jules David, engraved by A. Bodry. Numbered by the Artist 1844. Published in *Allgemline Moden-Zeitung*, Leipzig, 1875. *Collection of Mrs Langley Moore*

of unknown workmen or obscure artists, are treasure trove for the connoisseur and collector today; and it is some of those artists whose work I want to celebrate with illustrations and a few comments in this book.

I have written elsewhere about the often obscure narrative painters of the Victorian period, whose prolific output fell into neglect in the first decades of the present century but is now being avidly sought by collectors who cannot afford to buy the established masters. In the present book the only paintings I have been concerned with are some of the portraits of livestock produced in abundance by nineteenth-century painters for the gratification of those who bred, reared, or owned the spectacular beasts. These paintings, and engravings or mezzotints deriving from them, are as genuine an exercise in animal art as the 'pedigree' paintings collected and so generously brought to public attention in Britain and the United States by Mr Paul Mellon (one or two of which I have added, for comparison).

The main aim of this book is to draw attention to artifacts that have few pretensions to be 'fine art' but were produced purely for information, decoration or amusement. The choice of subjects was obviously restricted by the dimensions

of my book and by the limitations of my own knowledge. I do not pretend that my treatment of any of the subjects is in any way extensive or authoritative: my purpose is simply to draw attention to minor expressions of the Victorian outlook that have not always received their due of study and appreciation. Wherever possible I have mentioned the more substantial monographs on each subject, though it is surprising – and lamentable – that so little scholarly history and comment is now available.

Folk art is a term that has become fashionable, and it embraces many artifacts that are amusing and collectable, though not of much account from an aesthetic point of view. Old picture postcards and Christmas cards, for instance, have a curiosity interest, but with all respect to my friend Ronnie Barker, who has collected fifty thousand of them over the years, and has written two entertaining books about his collection, I feel no urge to add to the literature of the subject, much as I cherish my copies of Ronnie's *Pennyworth of Art*.

I could not, however, neglect so genuine a product of folk art as the valentine card, which has an ancient history, and of which the early Victorian examples retain something of the elegance and style of the Regency period, with the addition of a lot of Victorian frills and furbelows.

The nineteenth century was a period in which new techniques of printing and reproduction, such as the aquatint and the lithograph, were rapidly developed. It was, therefore, an era which gave great opportunities to book illustrators such as Rowlandson, Cruikshank, Phiz, Leech, Marcus Stone and Walter Crane; but much has been written about them, and any further study of their work would soon develop into a catalogue. Scholars such as Ruari McLean have already done justice to them.

My main concern here is to draw attention to, and reproduce some examples of, artifacts or decorative illustrations that have not, until today, ranked much higher than *ephemera*.

Nothing could be regarded as less 'important', less qualified for learned aesthetic assessment, than the children's samplers that used to be found in almost all homes, except the richest and the poorest, in the nineteenth century. They were worked by children of the household for their own amusement or edification, or else in schools as a form of elementary education. Yet, for this very reason, they are one of the purest forms of folk art. Though many of the constituent elements – flowers, images of trees or birds, houses and gardens, letters of the alphabet, and dates of birth, may be conventional – the child's conception of the subject is often distinctly original, and the composition, layout and spacing an ingenious exercise in design.

Another form of decorative art which was produced in vast quantities throughout the nineteenth century was the hand-coloured fashion plate. This cannot be regarded as a folk art: on the contrary it is a sophisticated combination of the talents of accomplished draughtsmen or women, skilled engravers, and masters of newly invented printing processes.

Because of the obvious limitation of the number of colour plates available, I have not been able to do full justice to the French fashion plates of the nineteenth century, but the artists involved created an art form which, although essentially utilitarian in purpose, was in my view one of the outstanding decorative achievements of the century.

Especially do I recommend to the attention of collectors and students of Victoriana the three thousand or so fashion plates produced between 1843 and 1892 by Jules David. Although the two chief historians of the fashion

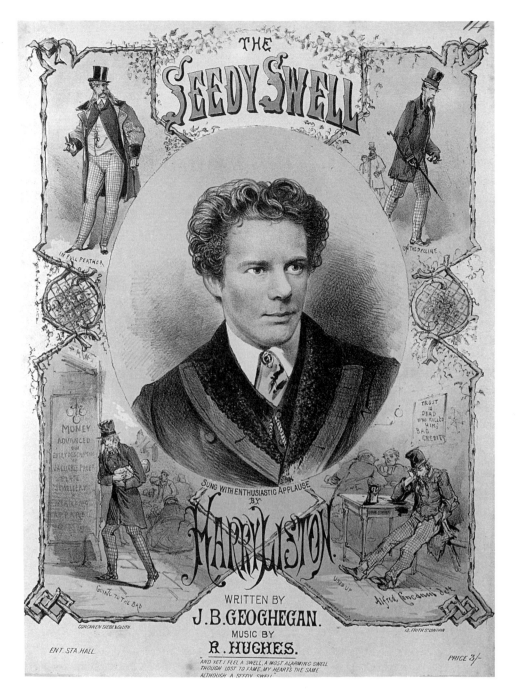

plate, Vyvyan Holland and Doris Langley Moore, recognised the artistic ascendancy of David, it seems to me amazing that David has not yet been the subject of a full-length study by an art historian. Perhaps one reason is that fashion plates are still considered a minor and restricted art form. Another reason may be the difficulty modern printers experience in competing with the softness and colour-variation of the original hand-coloured plates, which clearly owed much of their aesthetic charm to the kind of ill-paid manual labour which is not available to printers today.

Another minor art form of the Victorian era which has been astonishingly neglected by art historians is the lithographic music cover, or title page, that came into being in England in the eighteen-forties. Here, again, the impulse came from the development of printing techniques; and the enormous output

of lithographic music covers was largely made possible by the employment of what would now be regarded as slave labour. But the merits and distinction of the cover designs would not have been achieved without the availability of a group of exceptionally talented illustrative artists.

The music covers have what some aesthetes might regard as the disadvantage of the titles of the songs or dances being added in a variety of styles of lettering. But often the lettering itself has a delightful period quality. If the lettering were removed from the designs of some of the scenic artists, such as Brandard or Rosenthal, the pictures would challenge comparison with water-colour drawings by the most 'esteemed' painters of the period.

The work of the many excellent and now well-known topographical artists of the mid-nineteenth century was often challenged by the relatively obscure craftsmen who designed covers for the music of mazurkas, waltzes, gallops, polkas and quadrilles. In my own modest collection I have a cover for *Souvenir de Quebec*, a 'waltz for the piano forte by Emile Ettling', which bears a most elegant and detailed lithograph of the harbour of Quebec, filled with three-masters and fishing craft, with an impressive background of sea-front houses and fortifications on the cliffs. Only the engraver's name, J. Hardy, is given. Equally unusual, and beautifully composed, is Brandard's cover for *Queen of the Alps*, 'Valse by Charles d'Albert', which illustrates the 'Monte Rosa Procession of the May Queen' in a picturesque Swiss village with towering Alps in the background. A valuable record of marine transport is provided in the cover for *The Express Quadrille*, 'Descriptive of an Excursion to Paris and Back', written by Charles Coote (a name still current in the London theatre) for which the cover was produced by Thos. W. Lee, only known today as a partner of Alfred Concanen.

Yet another surprising sphere in which artists of the music cover excelled, and indeed showed great originality, was in marine botany. As I shall be mentioning later in this book, the mid-Victorian era was prolific in students of natural history, and there was a popular vogue for keeping fish and growing plants in aquaria. I have a superb composition by Thomas Packer which forms the cover for the *Sea Shells Polka* by William Smallwood. The design is made up from sea shells surrounded by aquatic plants with a striking pendulous splash of pure gold in the centre, beyond which there is a vista of cliff and rocks going down to the sea. From an aesthetic point of view, I can only describe it as a 'knock-out'. If any artist of today could emulate this treatment and exhibit his work in a West End gallery, I am sure collectors would flock to see it.

However, it is not only for their aesthetic merits that we value the Victorian music covers today. It is also for their entertainment value as social documents. Whereas the French fashion plates primarily provided vivid and accurate documentation of women's clothes, the English music covers recorded the robust way of life of a large part of the male population. Here are the men-about-town who twirled their canes and adjusted their monocles as they paraded down Bond Street, Piccadilly or the Front at Brighton. Here, too, are the ladies of the town, in their billowing crinolines, who ogled the mashers.

This was also the great era of the popular Music Hall, which reflected the common activities of the lower middle class and the working man, not merely *The Seedy Swell* on his progression from the pub to the pawnbrokers, as portrayed by Harry Liston, and the classic *Champagne Charlie* of George Leybourne, but also the gallery of little nondescripts and street-corner loungers enacted by Dan Leno, Albert Chevalier and Charles Coborn.

Whereas the low life of the mid-eighteenth century had been recorded for all time in such prints by Hogarth as 'Gin Lane', and the humours of the Regency coach or tavern by Rowlandson, so the popular ballads of the Victorian music hall represented the cockney jauntiness of the 'Old Bull and Bush'. The artists were there, in the gallery or at the back of the pit, to recreate the songs and their singers on the music covers. A collection of these will present to us Dan Leno singing *The Grass Widower* or *The Waiter*, W.B. Fair asking Tommy to *Make Room for Your Uncle* or Arthur Roberts celebrating the delights of *Oh, the Jubilee*.

A high proportion of such music covers were produced by that laureate of the Music Hall, Alfred Concanen, whose lithographic abundance is known only to collectors and theatrical historians today, but whose niche as a social historian is not far below those occupied by Rowlandson or Gillray.

I am unable, in my ignorance, to parallel these English (or Irish, for Concanen came from County Galway) memorialists of the popular theatre with comparable artists in the United States, despite the significant contribution to popular song and dance made by American composers. But there is a byway of American art which has always amused me and is certainly of importance in the history of photography. This is the 'cabinet photograph' which was developed as a curious specialised art form by a small group of theatrical portraitists between the 'sixties and the turn of the century. It may surprise some readers to refer to them as 'pioneers of the pin-up'. But that is historically what they were, though they themselves preferred to be known as artists in 'glamour photography'.

Their influence and ingenuity soon became evident in photographic studios in London and Paris, but they were originally an American conception, celebrating the sexual charms of the stars of the American burlesque theatre. The chief photographers were Sarony, Moro, Howell and Falk.

Although London photographers were quick to learn new tricks of the trade from innovators in the United States, and glamour photographs of Lily Langtry, Vesta Tilley and other ladies of the British music hall were in circulation by the end of the century, there was nothing in England quite comparable with the American burlesque theatre until ragtime came to London in the early twentieth century.

There was, however, one popular art form that had emerged from the British theatre in the Regency period, and which flourished throughout the nineteenth century. This was the Toy Theatre or, as it can more grandiloquently be termed, the Juvenile Drama. Although it sometimes derived its themes from plays by Shakespeare, and its characters were frequently modelled on such eminent figures in the legitimate theatre as Edmund Kean, Mrs Siddons, the Kembles and Macready, it developed essentially as a folk art, its artists being journeymen draughtsmen whose names are now forgotten, and its producers being back-street printers. The market was almost entirely juvenile. The commercial approach has been summed up for all time in the phrase 'Penny Plain Twopence Coloured'.

I pretend to no special knowledge of the Juvenile Drama, but have had the pleasure of seeing some of its productions performed by my friend George Speaight, a famous puppeteer and author of the standard *History of the English Toy Theatre*. He has also been kind enough to lend me some rare prints from his collection, including Leech's original hand-coloured etchings illustrating the assembly of a toy theatre and its performance in a mid-Victorian family. These are reproduced now in colour for the first time since

12

On the right: one of the classics of the Juvenile Drama. A scene from *The Red Rover* being enacted in an early Pollock proscenium. *The Red Rover* was a popular nautical melodrama based on a story by the American novelist, Fenimore Cooper. *Photograph by Edwin Smith*

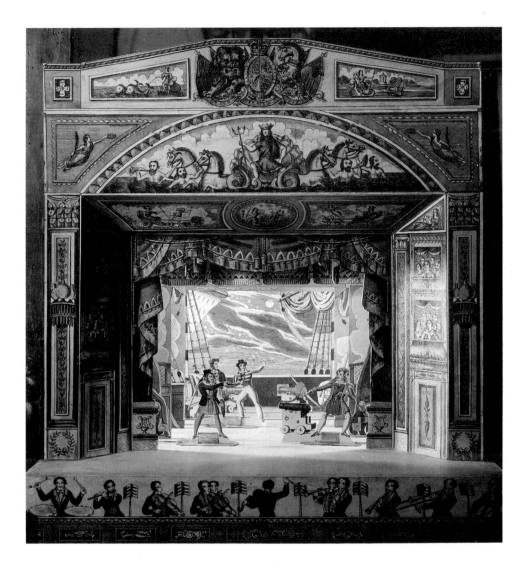

their publication in *Young Troublesome, or Master Jacky's Holidays*, in 1845.

Thanks to the efforts of Mr Speaight and other enthusiasts such as Sir Ralph Richardson, the most famous of producers of toy theatres and juvenile drama sheets, the firm of Pollock of Hoxton, was revived under new management in the nineteen-thirties and continued to sell theatres, scenery and reprints of earlier Pollock sheets in a shop off Tottenham Court Road. Here, therefore, is a folk art of considerable antiquity which has retained its appeal and has been able to market its traditional products until the present day.

There is another quite different form of folk art, however, that has almost disappeared from the market, though still retaining its strong appeal to collectors. Of all the collectable pieces of English pottery that could be found in plenty of antique shops and auction sales as recently as the nineteen-thirties the most attractive to collectors of modest means were what had become known generically (but not always accurately) as Staffordshire figures. Those dating from the eighteenth century, made by Astbury, Whieldon, Wedgwood and Ralph Wood, had become rare and costly, even in the nineteen-twenties. But the humbler Victorian figures, produced originally for sale at country fairs, to decorate the chimneypieces of cottages and farmhouses, were still plentiful, and available at prices which modest collectors could afford.

Not so today. Their prices have rocketed, and, even worse, the supply has

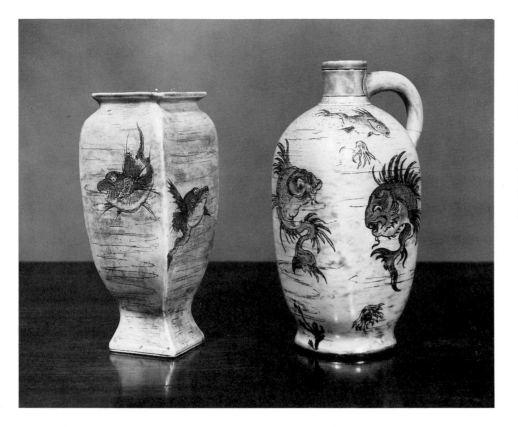

Martinware, made by the Martin Brothers at Southall, 1899.

On the left a soft grey-blue vase decorated with fish in greenish brown, 122mm high; *Miss Priscilla Greville*

On the right: a buff pitcher, with some touches of blue, the fish in brown, 192mm high. *Private Collection*

virtually dried up. This has happened not merely because of the decline in the value of money, but also because this was a hitherto unrecognised reservoir of simple folk art of which collectors, especially in the United States, suddenly began to recognise the aesthetic value.

I mentioned earlier in this Introduction my inheritance of two Walton groups that had been acquired by my great-grandfather in the eighteen-forties. These opened up for me a field of connoisseurship that gave me much simple pleasure as a young collector, and which I began to study seriously soon after 1920, when Herbert Read (before becoming a distinguished literary critic) published a pioneer book on *Staffordshire Pottery Figures*. Short-sightedly, during the ensuing years I assumed that the more common figures would continue to be in plentiful supply at prices of a few shillings. Whilst I took great pleasure in looking at examples in museums and in other people's houses, I didn't start to collect them seriously until the price rose not only to pounds, but, in due course, to hundreds of pounds!

What I want to stress, however, is not the extraordinary recent rise in the financial value of Staffordshire chimneypiece ornaments, but their quality as products of the potter's art, and their amusingness as reflections of the social life of their period.

Another small section of this book, illustrating pottery portrait figures, is of interest as a rather later and different social commentary, of interest historically in that the majority of the figures represent identifiable and well-known people. But in my opinion they tend to lack the individuality and ceramic charm of the earlier and less pretentious pottery figures, and they were run off in large quantities by unskilled labour, mostly by the firm of Sampson Smith.

In contrast to the makers of these attractive but purely commercial products,

though to some extent overlapping in date, were the few individual ceramic enthusiasts who set up their kilns in the 'seventies and 'eighties and who are often referred to as 'artist potters'. I propose to pass by the various skilled craftsmen who worked for the large and famous firms of Doulton, Pilkington and Minton, as I cannot summon up much enthusiasm for their works, valuable though they may be in the sale rooms today. Too often they over-elaborate, not in the homely naivety of such artifacts as the barge teapots produced beside the canals at Church Gresley, but with a sophisticated super-abundance of decoration likely to impress visitors to the International Exhibition of 1862. Much of their work seems to me to deserve little more than the classification of 'good bad art'.

But the individual artist potters, who continued to contribute so much interesting work in the twentieth century, do deserve some celebration, how-ever brief it may have to be in this book. I take two names as representing the emergence of individual artistry in ceramics. I do not myself respond to the grotesque human heads and birds designed by the Martin Brothers at Fulham and Southall (1873–1914) but their more traditional wares, which show a certain oriental influence, are extremely pleasing to my eye. So, too, was almost all the output of William de Morgan and his artists at Merton Abbey. Indeed his name can be mentioned in the same breath as that of the command-ing genius of Victorian arts and crafts, William Morris.

In a different sphere, and a different medium, is a group of artists who would perhaps be surprised if they knew that today they were being esteemed as artists rather than what they prided themselves on being – naturalists. Admittedly one of them, Edward Lear, only *began* his working career as a naturalist, and at quite an early stage decided that landscape art meant more to him than biology. In the brief period, however, between his eighteenth and twentieth birthdays, he produced one of the most remarkable series of ornitho-logical paintings of the many that appeared in Victoria's reign, his *Illustrations of the Family of Psittacidae, or Parrots*. It is only in recent years that Lear's extraordinary promise as an ornithological painter has been generally recog-nised: even today he is much more widely known for *A Book of Nonsense* and his watercolour drawings of European and Asiatic landscapes.

As an ornithological artist Lear's thunder was stolen by John Gould, the friend and mentor of his early years, whose magnificent folio studies of *The Birds of Europe*, *The Birds of Britain* and *The Birds of Australia*, have come to be regarded as the most important books about birds published in the nine-teenth century. They are indeed magnificent, but Gould himself can claim relatively little credit for them as an artist. He began by copying the format of Lear's *Parrots*, and in fact commissioned Lear to make many of the drawings for his own books, without making any acknowledgement of Lear's work. Gould, in fact, was more of an impresario – a brilliant impresario, with wide-ranging zoological knowledge, but his claims to have been himself an accomplished draughtsman are distinctly suspect.

The Victorian Age was a golden age for natural history, which became the chief recreational interest for countless ladies with an artistic bent. One of the most talented and prolific of these was Anne Pratt, who had a number of books on botany published by the Society for the Promotion of Christian Knowledge. I gather from experts that she does not now rank very highly as a botanist, but her innumerable watercolour drawings have a formal elegance and sense of composition that would today be regarded as highly professional.

Anne Pratt was only one of many women who excelled in illustration of

plants and flowers. Perhaps the best known today is Marianne North, whose paintings are to be seen at Kew. It should also be noted that Beatrix Potter, before she became the creator of Peter Rabbit and other immortals of the twentieth-century nursery, was a very talented painter of flowers, moths, butterflies and small mammals, when still in her teens. In the eighteen-seventies she drew a series of watercolours of toadstools and mushrooms that earned the approbation of professional mycologists, and she wrote a paper on fungi that was read before the Linnean Society of London.

There were probably hundreds of other young women in the mid-Victorian period who had as much scientific curiosity and even artistic talent as Beatrix Potter, but for the most part their gifts were only recognised in the nursery and the parlour. There were a few exceptions, such as Mary Anning of Lyme Regis, daughter of a carpenter, who, when she was only eleven years old, became famous as a collector of fossils. She found in 1828 a fossil of the pterosaur, the first relic of a flying reptile ever found in Britain. But she seems to have had little artistic faculty.

As I have mentioned earlier, the development of the aquarium as an object of household ornament and interest did much to arouse interest in marine botany. A Mrs A.W. Griffiths of Torquay became sufficiently famous for several species of seaweed to be named after her. But today a certain Victorian marine botanist of considerable importance in his day, and an artist of quite astonishing accomplishment, is chiefly remembered only as the father of the literary critic, Sir Edmund Gosse, who wrote a fascinating character study of him in a book called *Father and Son*.

In his lifetime Dr Philip Gosse attained some fame as the author of popular books such as *A Naturalist's Rambles on the Devonshire Coast* (1853) and *The Aquarium* (1854). Eventually he became a Fellow of the Royal Society. But I want to celebrate him in this book not for his scientific research, nor for the religious bigotry that looms so large in his son's biography, but for the extraordinary originality and beauty of his marine paintings. I am astonished that they are now so little known to the world at large. All his books have long been out-of-print, and they are impossible to reprint in their original form. But I regard Philip Gosse as perhaps the most original and distinctive artist of all those mentioned in this book.

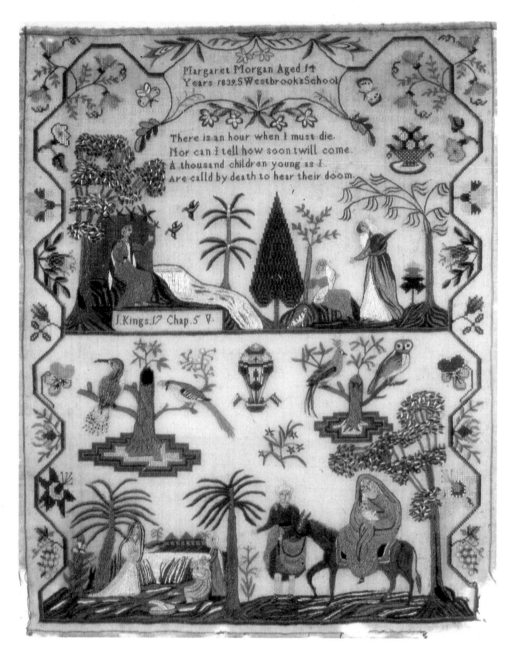

17

Above: Sampler worked
by Margaret Morgan,
aged 14 years, 1839, at
Westbrook's School,
Pontypool. On woollen
canvas, embroidered with
coloured silks in cross,
stem, satin, laid and dot
stitches and French
knots. It depicts Elijah
fed by ravens, the finding
of Moses, and the flight
into Egypt. There is also
a woman holding a birch
and a balloon with two
passengers. 218 × 120mm.
*Welsh Folk Museum,
St Fagan's*

NTIL THE FIRST WORLD WAR it was usual to find in most
middle-class family homes in Britain and the United States
one or two needlework samplers hanging on the walls. They
would usually have been worked several generations ago by
children of the household, under the guidance of their elders,
or in school.

From the sixteenth century until the end of the nineteenth, skill in needle-
work was considered an essential element in a girl's education. Samplers
served the dual purpose of teaching children how to sew, and to learn the
letters of the alphabet. During the seventeenth and eighteenth centuries the
patterns of samplers were worked mostly in vertical or horizontal lines,
embodying geometrical units or letters of the alphabet, which sometimes
denoted the child's name and age, with the date, embellished with floral
motifs and figures of trees or birds. As time went on, and the child's education
developed, a few lines of pious or sentimental verse might be added.

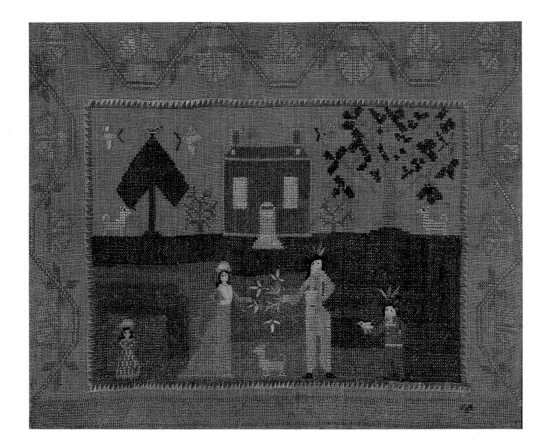

On the left: a needlework sampler signed by Phoebe Crawford, indistinctly dated 1804. Probably from Philadelphia. In blue, pink, yellow, green and white silk thread, mostly in cross stitch and stem stitch, on a linen ground. An Indian and his son, wearing feathered head-dresses, offer flowers to a young woman in blue and her daughter. 380 × 480mm.
Private Collection: photograph by courtesy of Sheila and Edwin Rideout, Wiscasset, Maine

18

On the right: a sampler worked by Elizabeth Harvey, finished September 10, in the 9th year of her age, 1811. Fine woollen material embroidered with coloured silks. The main stitches are cross, satin, long and short and stem. The sampler depicts Noah and his wife and three sons, Shem, Ham and Japhet. From Penarth, Glamorgan. 380 × 330mm. *Welsh Folk Museum, St Fagan's*

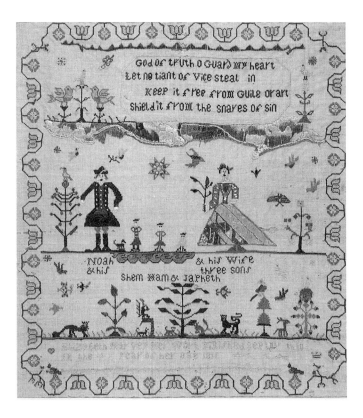

The sampler on the right
is typical of the elements
found in samplers of the
Delaware Valley of New
Jersey. Although not
dated it typifies the 1830's
period, when alphabet
and numerals had given
way to a more pictorial
treatment. It is executed
in a silk double
cross-stitch, with trees
and foliage in stem stitch.
The outline of the rose
border is in watercolour,
and may be a later
embellishment.
502 × 530mm.
Private Collection:
photograph by courtesy of
Sheila and Edwin Rideout,
Wiscasset, Maine

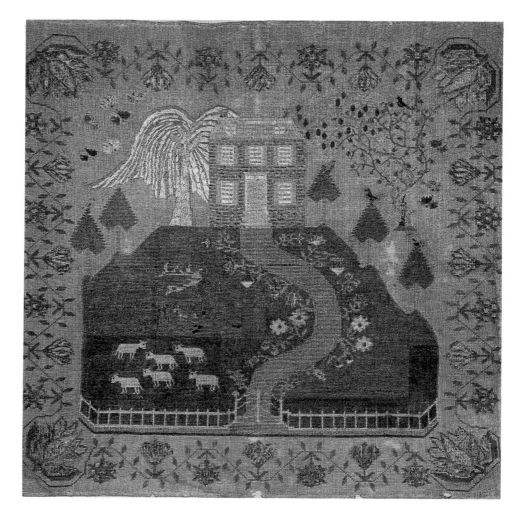

Beautiful and interesting though the early samplers were, it was not until
the end of the eighteenth century that the formalised patterns, with their
essentially geometric character, gave way to scenic compositions, more free in
style and invention, though still embellished with flowers, birds, trees and
other natural emblems, and the artist's name and age, and often a few lines of
verse at the top.

About this period children began to include images of the houses in which
they lived, and the gardens which surrounded them, usually drawn out of
perspective, and populated with rather stiff figures of people, sheep and dogs.
The 1839 sampler reproduced on page 17 includes an air-balloon. More
surprisingly, there is in the Bethnal Green Museum in London a child's
sampler dated as early as 1786 in which the conventional pious verse and
floral emblems frame an ascending balloon adorned with a French flag a
decidedly topical touch as Montgolfier's first successful ascent in a balloon
had only just occurred, in 1783.

From this time on, samplers became more adventurous in conception and
design; and throughout the nineteenth century, whether under parental guidance
or the influence of that all-important Victorian figure, the governess, samplers
developed into one of the most delightful and inventive expressions of child
art. The arrangement of the various elements often shows an instinctive sense
of spacing and design. In an entertaining example amongst the six hundred
samplers preserved in the wonderful collection at St Fagan's by the Welsh

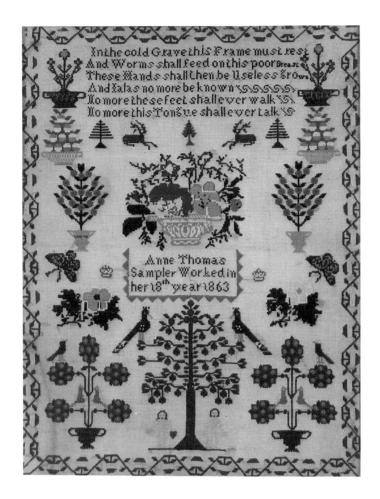

On the left: a sampler worked by Anne Thomas in her 18th year, 1863. Embroidered on canvas with coloured wools and black silk in tent, cross and satin stitches. From the Swansea Valley. At the top is the following verse:

In the cold Grave
 This Frame must rest
And Worms shall feed
 On this poor Breast
These Hands shall then
 Be Useless grown
And I alas no more
 Be known
No more these feet
 Shall ever walk
No more this Tongue
 Shall ever talk

Below the bowl of flowers are Adam and Eve and the Tree. *Welsh Folk Museum, St Fagan's*

20

On the right: a sampler worked by Mary Anne Hibbert, aged 9 years in 1826. Embroidered with coloured silks in cross and satin stitches. From Glamorgan. 384 × 240mm. *Welsh Folk Museum, St Fagan's*

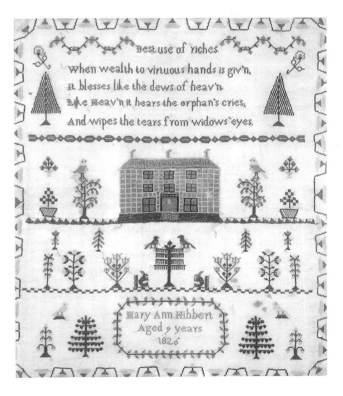

Sampler on linen canvas embroidered with coloured wools in cross stitch. In the middle is an inscription in Welsh. Worked by Gaenor Edwards of Llandderfel, Merioneth, at a school in Oswestry. 220 × 165mm. *Welsh Folk Museum, St Fagan's*

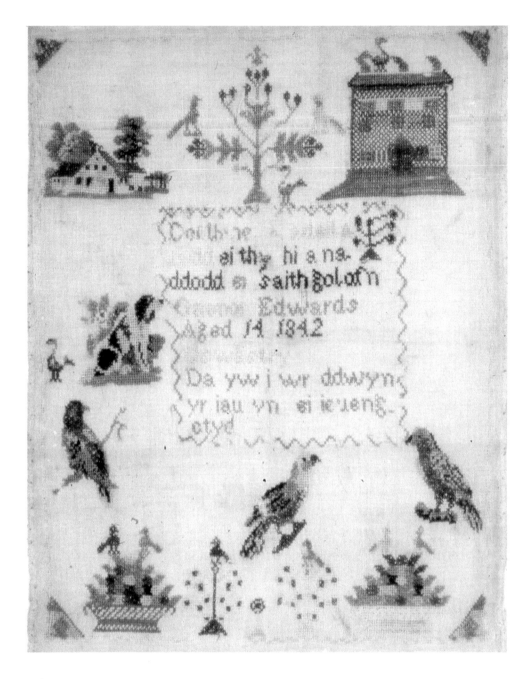

Folk Museum, the usual lines of pious verse at the head of the design are elegantly, if a trifle incongruously, set above images of Noah and his wife, wearing what would appear to be early Victorian costume, alongside tiny figures of their three sons, Shem, Ham and Japhet, accompanied by a very small dog.

In 1852 Mary Diggle, whilst retaining the conventional floral border, celebrated the birth or birthday of William and Emma Crompton, twin brother and sister, in a surprisingly well-drawn figure group, kneeling in a cornfield. For a child artist of eleven years this is a singularly sophisticated little work of art.

It is scarcely surprising that skilled needlework such as this, which may well have been thrown on the rubbish heap when families were dispersed in the mid-twentieth century, is now avidly sought after by collectors in Britain and the United States, and is sold by antique dealers at figures reaching into hundreds of pounds or dollars.

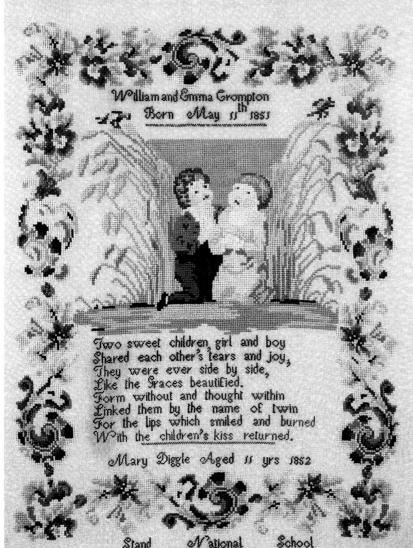

A sampler celebrating the birth on May 11, 1851, of twin children, William and Emma Crompton. Worked in coloured wools by Mary Diggle, aged eleven years, at Stand National School in 1852. 560 × 294mm. *By courtesy of Christie's, South Kensington*

22

On the right: a sampler by Mary Anne Robinson, dated 1835, possibly worked in India by the daughter of any army officer or missionary or Indian Civil Serviceman. Formerly in the Brooks Weld Collection. 620 × 295mm. *Private Collection: photograph by courtesy of Sheila and Edwin Rideout*

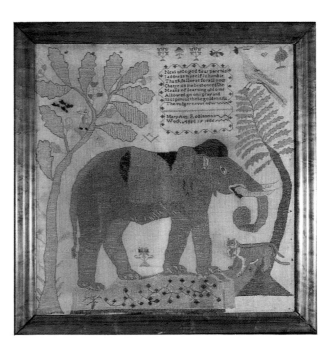

A sampler worked by
Mary Ann Randell, aged
ten years, 1886, in
brightly coloured wools.
610 × 660mm. *By
courtesy of Christie's,
South Kensington*

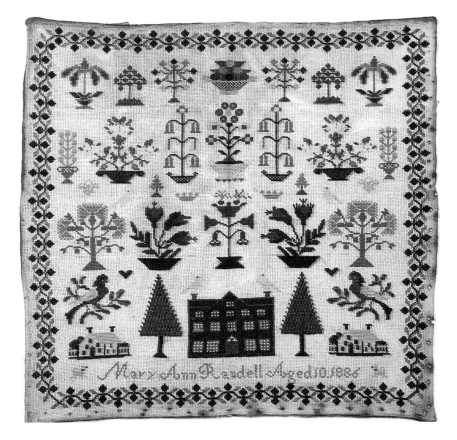

A book by Donald King, illustrating (in monochrome) 89 samplers in the Victoria and Albert Museum, was issued by H.M. Stationery Office in 1960. A historical study, *Samplers Yesterday and Today* (Batsford, 1964), by Averil Colby, contains over 200 illustrations (only one in colour), and is probably the best basic book now available. There are many references to samplers in two books on embroidery by Mary Gostelow, but these are general studies of needlework techniques. A book on *American Samplers* by Ethel Stanwood Bolton and Eva Johnston Coe was published in Boston in 1921, and a paperback edition was issued by Dover Books in 1973. Other American books are on *New England Samplers to 1840*, by Glee Krueger (Old Sturbridge Village, Mass., 1978), and *A Gallery of American Samplers, in the Theodore Kapnek Collection*, by Glee Krueger (Dutton, in association with the Museum of American Folk Art, 1978). Betty Ring published a book on Rhode Island Needlework with the Rhode Island Historical Society, Providence, in 1983.

In Britain there is abundant material available for study. The Victoria and Albert Museum has many outstanding examples; so has the Museum of London. There is a selection of over a hundred in the Royal Scottish Museum; and a descriptive handlist of them, with illustrations – though not in colour – was prepared by Naomi Tarrant in 1978. There are also collections of samplers in the Bristol Art Gallery and the Guildford Museum. Probably the largest collection in Britain, however, is in the Welsh Folk Museum at St Fagan's, Cardiff. They are not all at present on view, but a comprehensive, annotated *Guide* was prepared by F.G. Payne, a former Keeper, in 1939. It is now out-of-print, but a copy is available for consultation. Outstanding collections in the United States are in the Henry Francis du Pont Winterthur Museum, near Wilmington, Delaware; the D.A.R. Museum, Washington, D.C., and the Cooper Hewitt Museum in New York City.

23

ROBABLY THE MOST ACCOMPLISHED minor art form which emerged to full glory in the nineteenth century was the fashion plate. In the second half of the eighteenth century several series of engravings after Moreau le Jeune had been published in France, which are usually known as *Le Monument du Costume*, but although they are exquisite works of art they are scenes of social life rather than designs for costume. One of the earliest series of coloured fashion plates was *La Gallerie des Modes*, which lasted from 1778 until 1787. This was not exclusively a fashion periodical, but depicted figures at the French Court and on the stage, though the clothes were carefully described. Towards the end of the eighteenth century various other periodicals appeared, including *The Lady's Magazine*, an English production, which started in 1770, but was not coloured until about 1790.

Heideloff's *Gallery of Fashion* first appeared in 1794, in monthly parts, each consisting of two aquatints beautifully coloured by hand. Unlike most of the contemporary French fashion magazines, which were of small octavo size, this was a handsome quarto. The figures depicted were engaged in various occupations such as singing at the harpsichord, strolling at the seaside, or driving in a berlin. Subscribers to the yearly volumes included not only members of the European royal families but artists such as Zoffany and picture dealers such as Colnaghi. *The Gallery of Fashion* continued until March 1803 and the total number of plates issued was 217. They are now, of course, extremely scarce.

The British printer and publisher John Bell, founder of the *Morning Post*, launched in 1806 *La Belle Assemblée* in two forms, one with plates coloured by hand. This changed ownership in 1832, when the editor became the Hon. Mrs Norton, the original of Meredith's *Diana of the Crossways*. In 1854 there was a further change of ownership, and *La Belle Assemblée* began to issue plates by Héloïse Leloir, printed and coloured by hand in France, and imported into England. This continued until 1869.

Another early nineteenth-century periodical which included fashion plates amongst various other features was Rudolph Ackermann's *Repository of Arts*, which came out in monthly parts between 1809 and 1828. Two or more fashion plates were included in each number, and were described in detail in the text; but there were many other plates, depicting buildings and furniture, engraved in aquatint by English artists such as Rowlandson and Pugin.

In 1829 a Parisian magazine appeared entitled *Le Follet Courrier des Salons*, containing the most elegant fashion plates yet produced in France. This marked the beginning of the ascendency of the French artists, though Vyvyan Holland in his book on fashion plates says that 'their charm owes a great deal to the absurdity of the fashions of the early 1830s, with their exaggerated sloping shoulders, leg-of-mutton sleeves and vast collars'.

In the same year Henri de Giradin founded *La Mode*, which continued in circulation for twenty-five years, and was notable for including in its first two years weekly fashion plates by the charming lithographer Gavarni, who had a great gift for drawing children at play.

The next fifty or sixty years are the great period of the hand-coloured French fashion print. *Le Journal de Demoiselles* was launched in 1833 and *Le Bon Ton* in 1834. *Le Journal des Demoiselles* continued into the twentieth century. These and other French journals of the 'thirties introduced the work of the most talented fashion-plate designers, including Paquet, Portier, de Taverne and Laure Noel, who began when only nineteen years of age.

24

Ladies in plain calico Morning Dresses. Aquatint by Wilhelm von Heideloff for *The Gallery of Fashion*, August 1794. *The British Library*

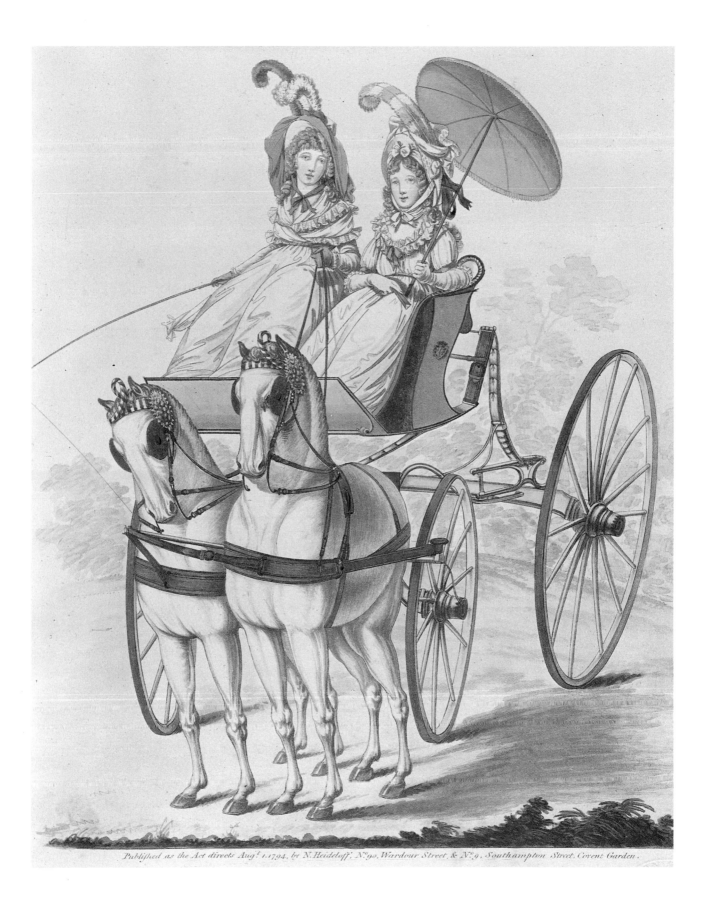

Published as the Act directs Aug.ᵗ 1.1794, by N.Heideloff. N.ᵒ 90, Wardour Street, & N.ᵒ 9, Southampton Street, Covent Garden.

25

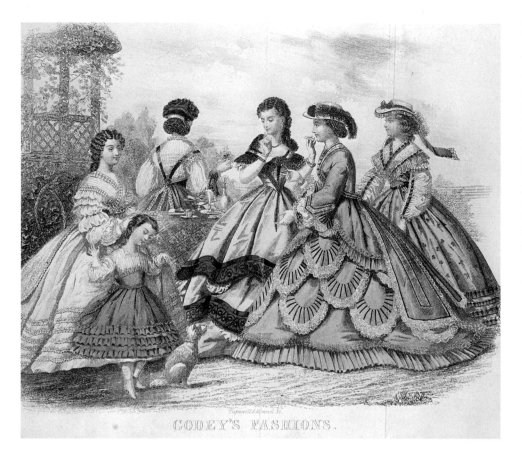

GODEY'S FASHIONS.

Left: *Godey's Fashions*,
1863, published in
*Godey's Lady's
Magazine*, Philadelphia.
Artist unknown.
Engraved by Capewell &
Kimmel, presumably in
the United States.
Mrs Langley Moore
points out a feature of this
plate which distinguishes
it from French plates of
the period, namely the
undulating hair, seldom
found in European
drawings of the time.
*Collection of Mrs Langley
Moore*

Although the inspiration of the fashion plates came – like the fashions themselves – from France, their influence spread rapidly in England, where *The Englishwoman's Domestic Magazine* was founded in 1852 by Samuel Beeton, husband of the Mrs Beeton who wrote the famous cookery book. In 1860 Beeton followed the example of *La Belle Assemblée* and began to import coloured fashion plates from Paris, including many by Jules David from the *Moniteur de la Mode*. In 1861 Beeton founded *The Queen*, which he sold in the following year to William Edward Cox, who revitalized it with French fashion plates by A. Paquet, E. Préval, Guido Gonin and Isabelle Toudouze, the daughter of Anaïs Toudouze.

In due course many of the best plates in the French magazines were imported into England and inserted in English magazines, but in some cases the American publishers had got in first, with copies of French originals made possible by there being no international laws of copyright. One of the chief American fashion magazines was *Godeys Lady's Magazine*.

The three artist daughters of Alexandre-Marie Colin, who became Héloïse Leloir; Anaïs Toudouze and Laure Noel, formed an outstanding trio of French fashion-plate designers, and even continued into the next generation with the daughter of Anaïs, Isabelle. There was a male artist, however, who dominated the fashion-plate market for fifty years, during which he produced nearly three thousand prints for *Le Moniteur de la Mode*, all signed and numbered consecutively. They were 'syndicated' to magazines throughout the world, and in England were published in *The Englishwoman's Domestic Magazine, The Milliner and Dressmaker* and other periodicals.

Jules David, of whose private life little is known, is notable not only for his industry and longevity, but for his originality. His dresses were meticulously

26

Opposite: A fashion plate
drawn by Héloïse Colin,
one of the three daughters
of Alexandre-Marie
Colin, who became better
known under her married
name of Héloïse Leloir.
Published in the *Young
Ladies Journal*, March 1,
1869. *Collection of
Mrs Edwin Smith*

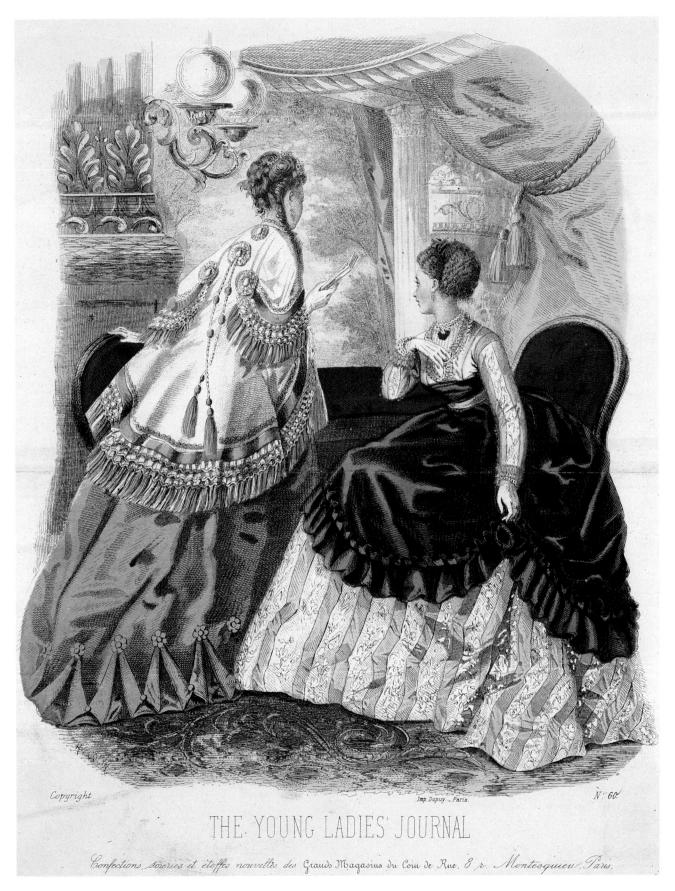

Imp. Dupuy. — Paris.

THE YOUNG LADIES' JOURNAL

Confections, soieries et étoffes nouvelles des Grands Magasins du Coin de Rue, 8 r. Montesquieu. Paris.

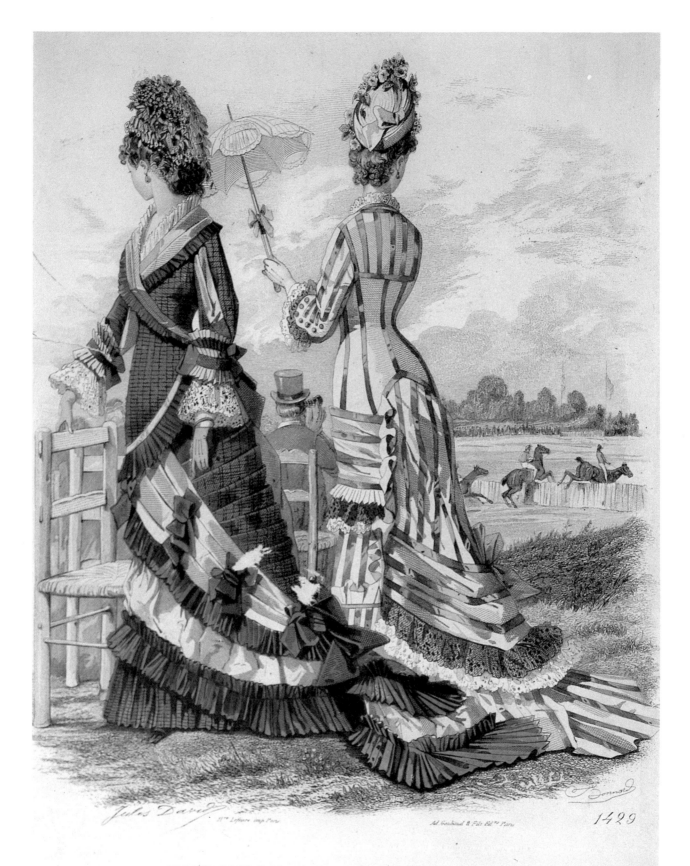

THE MILLINER & DRESSMAKER

AND

The plates on these pages show Jules David's work at its most characteristic. Opposite is a race-course scene published in its English version in *The Milliner and Draper* in 1877. *Photograph by courtesy of Christie's, South Kensington*

That on the right illustrates the more subdued fashions of 1886, towards the end of David's long working life. The crinoline had long departed, and the bustle had become as Mrs Langley Moore, puts it, 'a sort of cage like a lobster pot, which could be pushed aside when the wearer sat down, which was not as difficult as it looked'. *Author's Collection*

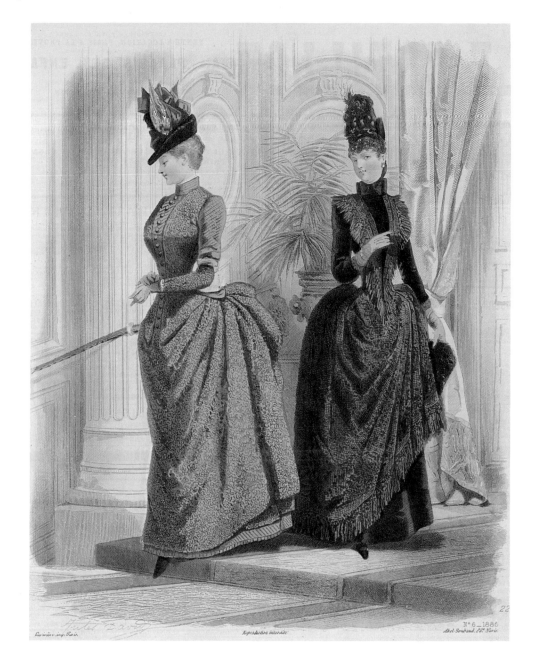

drawn, especially in the golden age of ladies' fashions, the 'forties to the 'sixties, but he liked to represent his figures against elaborate social backgrounds – garden parties, salons, race-courses, by the seaside, going to the opera, engaged in archery, or disporting themselves on swings. They therefore have the same social-historical value as the English conversation pieces of the previous century. To my mind they form one of the most substantial and important artistic achievements of the mid-Victorian age.

There were other fashion-artists, of course, since there was an outpouring of different fashion journals until the Franco-Prussian war. Many of the artists were anonymous and did not sign their work, but a very high standard was achieved by François-Claudius Comte-Calix, in *Les Modes Parisiennes*, and by A. de Taverne in *Le Journal des Demoiselles* and *Le Petit Courrier des Dames*. After the death of Jules David in 1892 his place was taken in *Le Moniteur de la Mode* by Guido Gonin.

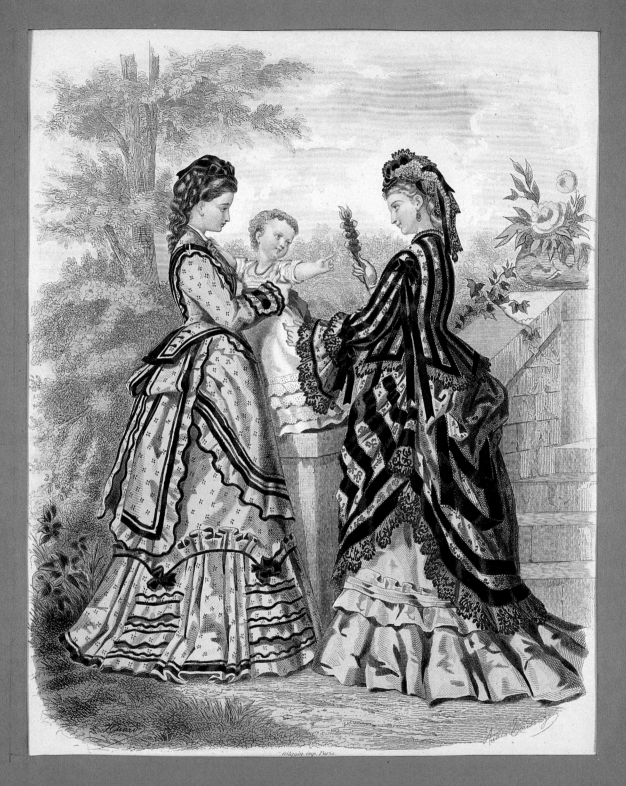

Gilquin imp. Paris

Anaïs Toudouze, who married G.A. Toudouze in 1845, was perhaps the most accomplished of the three daughters of Alexandre-Marie Colin. The fashion plate on the opposite page was engraved by Huard for *La Mode Illustrée*. *Collection of Mrs Langley Moore*

The plate on the right was drawn by her daughter Isabelle, who unquestion-ably inherited the family talent, and contributed to *Le Magasin des Demoiselles* and *La Mode Illustrée* as well as *Le Follet*, in which this boating scene appeared in 1875. It was sold in London by Edward Minter & Son. *Collection of Mrs Langley Moore*

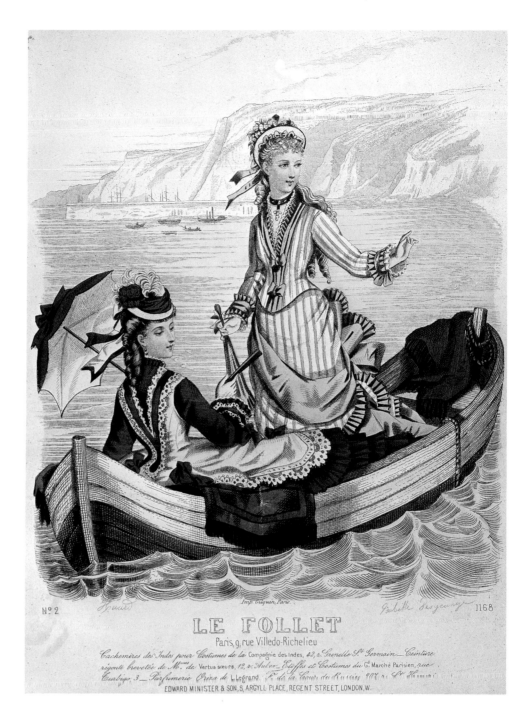

N.º 2 *Imp. Gilquin, Paris.* *Isabelle Desgrange* 1168

LE FOLLET

Paris, 9, rue Villedo-Richelieu

Cachemires des Indes pour Costumes de la Compagnie des Indes, 42, r. Grenelle St Germain — Ceinture régente brevetée de Mmes de Vertus sœurs, 12, r. Auber — Etoffes et Costumes du Gd Marché Parisien, rue Turbigo, 3 — Parfumerie Oriza de L. Legrand, F. de la Cour de Russie, 207, r. St Honoré.

EDWARD MINISTER & SON, 8, ARGYLL PLACE, REGENT STREET, LONDON, W.

Vyvyan Holland was a little ironical about the nautical details of the plate by Isabelle Toudouze, reproduced above. He pointed out the precarious situation of two young women at sea off the coast of Normandy in a boat with no oars, no rowlock and no rudder. Assuming, however, that a lifeboat would soon be coming to their rescue, he commented on their imperturbability, 'with parasol and fan, in readiness for the garden party to which, no doubt, they were on their way.' Are we, however, so very sure that they will get to their garden party at Dieppe or Trouville, or wherever it might be? I have a suspicion that the girls are, in every sense, all at sea. In view of the fact, as printed at the foot of the plate, that this is the British edition of *Le Follet*, the scene in the background may not be the coast of Normandy but 'the white cliffs of Dover'!

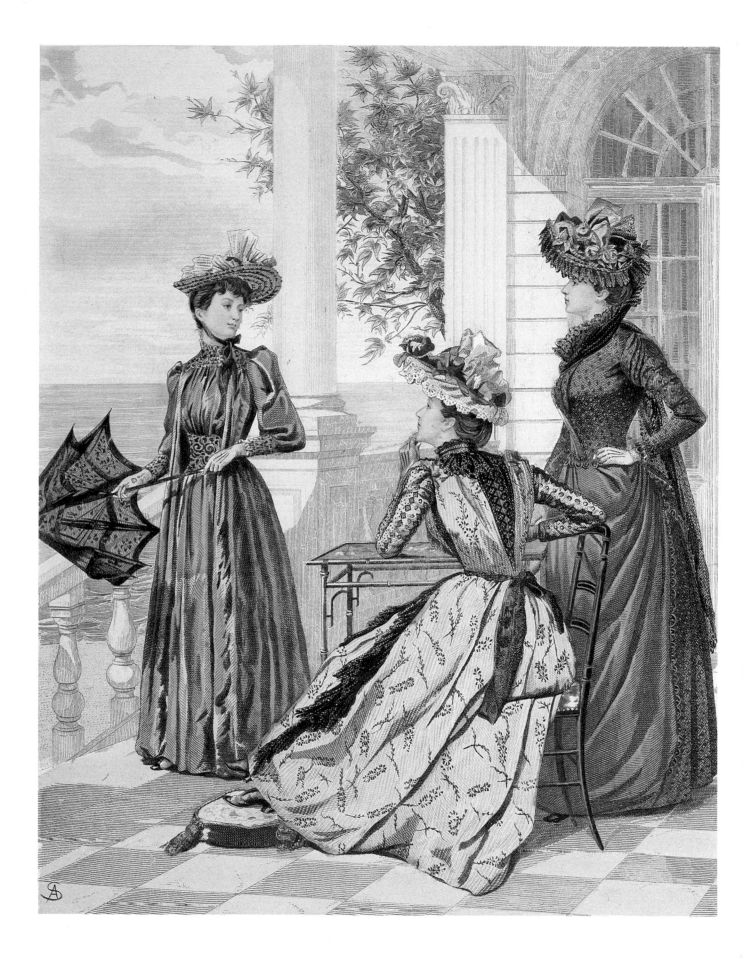

Opposite: one of the plates drawn for *The Queen* in 1889 by a mysterious artist whose work was signed with a monogram 'AS' or 'A. Sandoz'. Vyvyan Holland admitted that he knew nothing of the artist, not even whether it was a man or a woman. Mrs Langley Moore, before writing her *Fashion through Fashion Plates*, went to Paris where she met a friend of the artist, who turned out to be a Ukrainian *genre* painter called Adolf Karol Sandoz. Most of his work appeared in *The Queen* in the 'eighties and 'nineties. *Photograph by courtesy of Christie's, South Kensington*

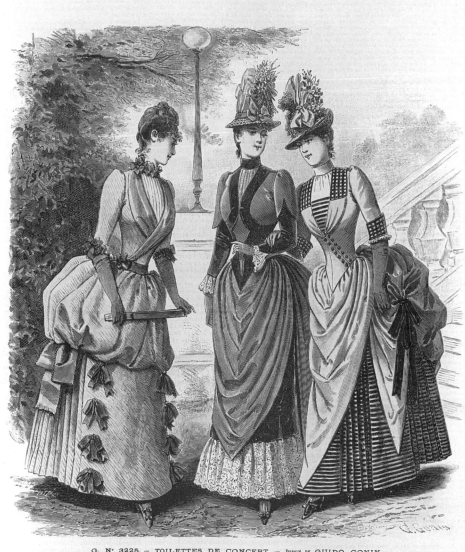

G. N° 3225. — TOILETTES DE CONCERT. — Dessin de GUIDO GONIN.

Modèles de Mᵐᵉˢ VIDAL. (104, rue de Richelieu).

33

Above: *Toilettes de Concert. Modelès de Mme. Vidal, 104 rue de Richelieu.* A plate drawn by Guido Gonin, who followed Jules David in the pages of *Le Moniteur de la Mode* in the eighteen-nineties. Like his predecessor, he numbered his plates. This one was E.3225. Almost all of us today know elderly ladies who actually dressed like this in their teens. *Author's Collection*

In the 'seventies the crinoline gave way to the bustle, and fashions became much more austere. One outstanding artist, A. Sandoz, emerged briefly in the 'nineties, and in *The Queen.* But in 1899 the last hand-coloured fashion plate appeared, and thereafter mechanical printing took over. It was the combination of meticulous draughtsmanship, skilled engraving, and hand-colouring in watercolours, that gave the French fashion-plate its unique quality.

The two outstanding books on fashion plates, both now out-of-print, are Vyvyan Holland's *Hand Coloured Fashion Plates, 1770–1899* (Batsford, 1955) and *Fashion through Fashion Plates, 1771–1970* by Doris Langley Moore (Ward Lock, 1971). Vyvyan Holland's book was a pioneer work of reference, with abundant monochrome illustrations but only five colour plates. It contains much biographical information about artists, and dated handlists of the chief periodicals in which fashion plates appeared. Mrs Langley Moore's book covers a longer period, and includes seventy-two colour plates, very well printed, in addition to ninety-three monochrome plates. Mrs Langley Moore was the founder of the Costume Museum at Bath, and her book emphasises changes in fashion rather than the artistic qualities of the plates.

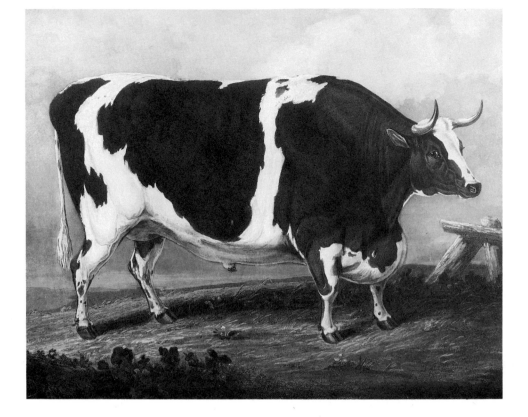

NE OF THE MINOR ARTS of the eighteenth century – though it was always one of the most popular – was animal painting, especially the painting of hunters, racehorses and hounds. Owing to the cost and social status of the sports in which these creatures of the chase were engaged their owners were for the most part landowning gentry or at least members of the squirearchy. Often they were men and women of inherited and aristocratic tastes, and the paintings they commissioned usually celebrated their sporting recreations, though some of the artists they employed such as George Stubbs, Sawrey Gilpin, George Barrett, Joseph Wright of Derby and Richard Reinagle, are now accepted as distinguished figures in the mainstream of British art.

With the coming of the industrial revolution in the last years of the eighteenth century there arose, for the first time in British social history, a substantial middle class, owners of their own businesses in industry, trade and agriculture, who were not directly dependant on the feudal system. They could, and did, participate in the simpler, humbler sports of their 'betters' such as shooting and fishing, and some of those who 'rose in the world' would dabble in beagling, trotting races and coursing.

For the farming community and men engaged in related trades, such as seedsmen, corn-factors, millers and maltsters, country auctioneers and surveyors, a new prestige symbol emerged in the form of pedigree livestock. And inevitably artists, engravers and printers were quick to turn to their advantage a new market for their skills. In a little time the engravings and aquatints of hunting and shooting scenes that hung on walls of the taprooms in country inns and taverns were joined by Bewick's engraving of the famous Chillingham Bull (1789), the Durham Ox, after John Boultbee (1802), and, as the years went by, a variety of short-horned cattle, famous ewes and rams, cart horses, even pedigree pigs.

34

Above: *The Bradwell Ox* (detail) a shorthorn ox, 'the greatest phenomenon of his species', belonging to William Spurgin of Bradwell, Essex. Aquatint after a painting by H.B. Chalon, 1830, dedicated to the Rt.Hon. Lord Viscount Althorp. *Rothamsted Experimental Station Library*

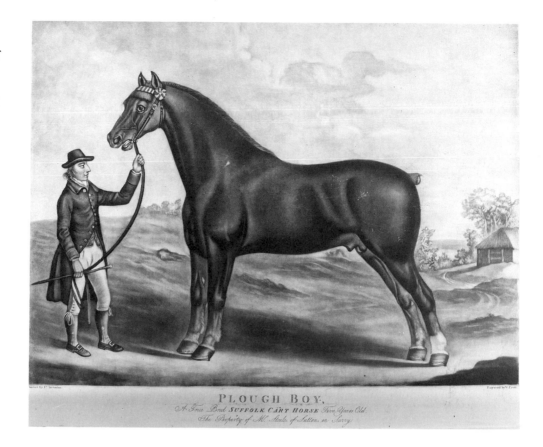

PLOUGH BOY,
A True Bred *SUFFOLK CART HORSE* Five Years Old.
The Property of Mʳ Steele of Sutton in Surry

A few of the painters of the chase turned their hand to this less fashionable
art form, including Francis Sartorius, the senior member of a well-known
family of fox-hunting painters. John Boultbee was a horse painter whose
work has often been mistaken for that of Stubbs. Henry Barraud, Henry
Barnard Chalon, William Henry Davies, 'Animal Painter to Her Majesty',
the former stable-boy Ben Marshall, Robert Pollard, even Landseer as a
young man, all tried their hands at farm livestock. But in general, the fox-
hunting artists did not demean themselves with such journeyman work.

And the fact is that the lines and proportions of farm livestock were not
such as to grace the walls of a gentleman's drawing room or a lady's boudoir
designed by the Adam brothers or Sir John Soane. For the owners of the
beasts, size and weight were dominant factors. Whether the animals were in
fact as grossly large as they appear in some of the engravings is debatable.
Thomas Bewick describes in his *Memoir* how he was summoned to paint
pedigree sheep and cattle and 'they were to be figured monstrously fat before
the owners of them could be pleased.' Painters were found who were subservient
to this guidance, and nothing else would satisfy the owners. On the other
hand, some of the engravings by the more reputable artists have the beasts'
dimensions precisely recorded in the descriptive legend at the foot of the page.
There is little doubt that in the eye of the interested beholder 'large was
beautiful.'

*Most of the illustrations which follow are reproduced from the remarkable
collection of prints and paintings in the Library of the Experimental Research
Station at Rothamsted in Hertfordshire.*

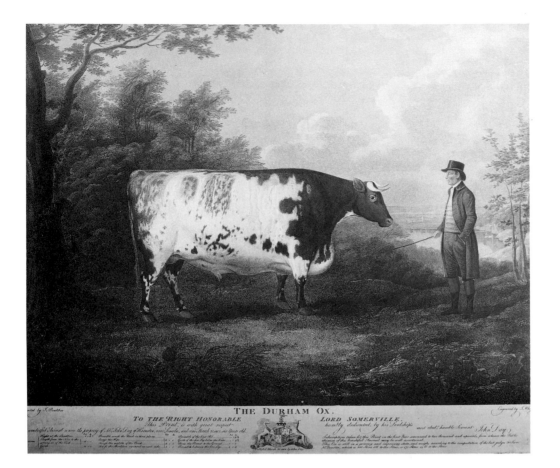

The Durham Ox. Etching printed in colour by John Whessell after a painting by John Boultbee. Published on 20 March 1802 by John Day. *Rothamsted Experimental Station Library*. The original painting by Boultbee is now in the collection of Lord Spencer at Althorp, Northants.

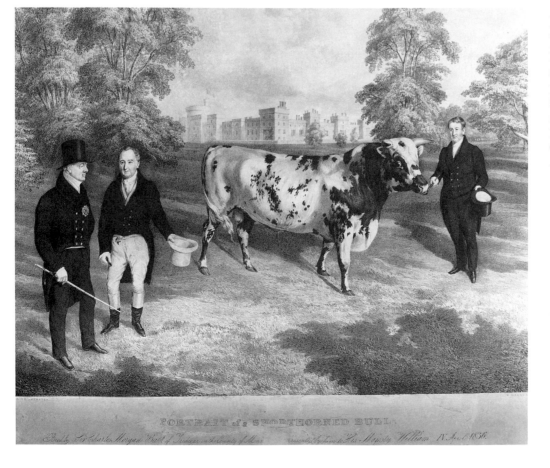

A Short-horned Bull presented by Sir Charles Morgan, of Tredegar, to King William IV, who stands on the left of the picture. In the background is Tredegar Castle. Lithograph by M. Gauci after a painting by J.H. Carter, c.1836.
Rothamsted Library

36

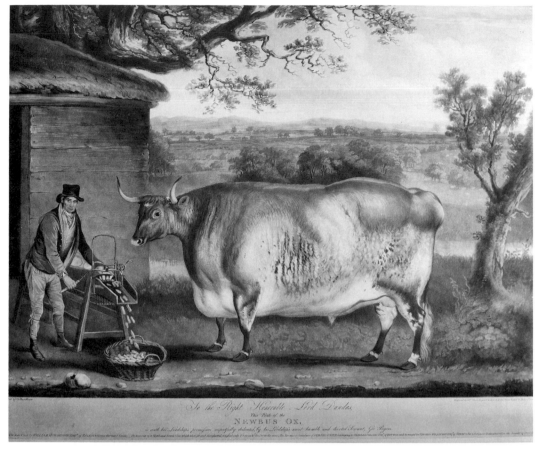

The Newbus Ox.
Mezzotint by William
Ward, after a painting by
Thomas Weaver, 1812.
Rothamsted Library

Two Durham Oxen.
Painting by Thomas
Weaver, 1827. *Virginia
Museum, Richmond,
Virginia. The gift of
Mr and Mrs Paul Mellon*

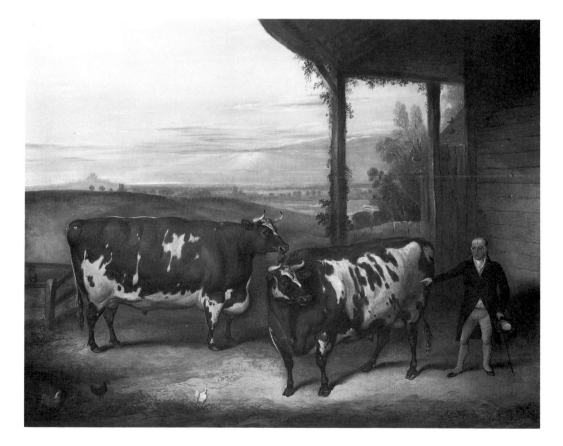

37

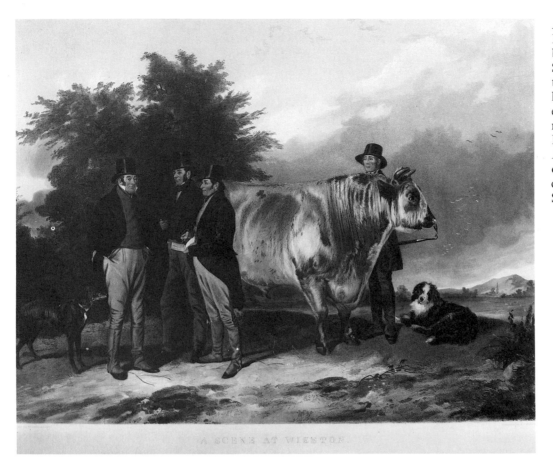

A Scene at Wiseton, with Lord Spencer's famous bull, Wiseton, the 3rd Earl Spencer (1782–1845), his two stewards and the herdsman. Mixed process engraving by W.H. Simmons after a painting by Richard Ansdell, 1844. *Rothamsted Library*. The original painting is in the collection of Lord Spencer at Althorp

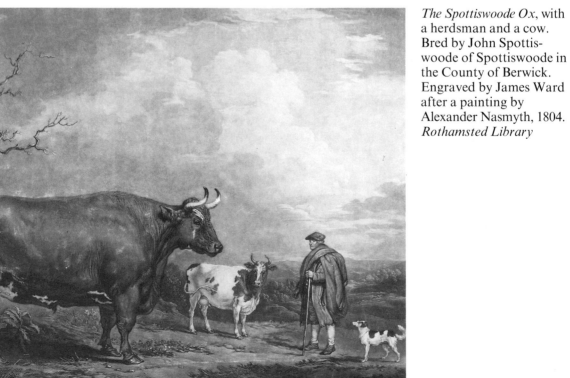

The Spottiswoode Ox, with a herdsman and a cow. Bred by John Spottiswoode of Spottiswoode in the County of Berwick. Engraved by James Ward after a painting by Alexander Nasmyth, 1804. *Rothamsted Library*

38

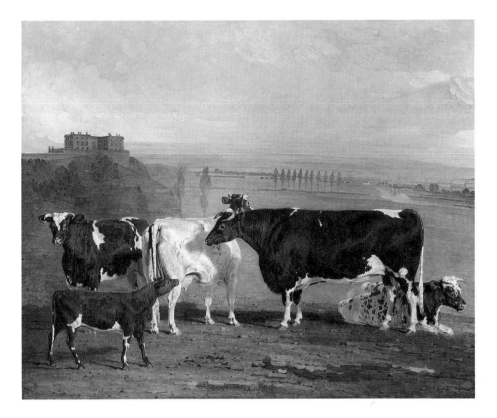

The Celebrated Bull, Alexander, a Shorthorn Bull, with three cows and a calf. Nottingham Castle in the background. Painting by Benjamin Marshall, 1816. *London, Tate Gallery*

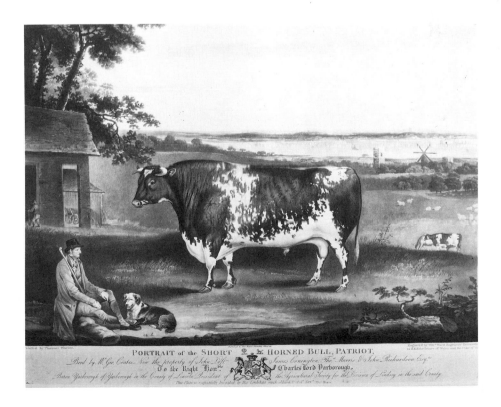

Patriot, a Short-horned Bull. Coloured mezzotint by William Ward after a painting by William Weaver, 1810. *Rothamsted Library*

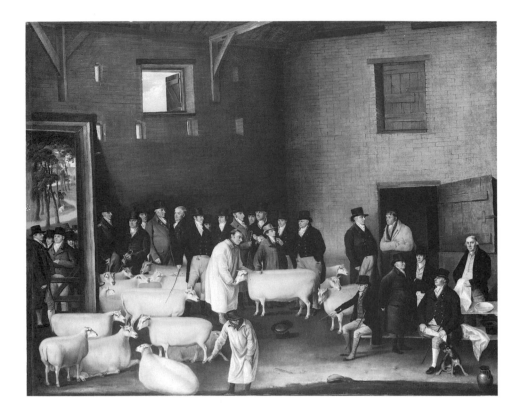

Ram-letting from Robert Bakewell's Breed, at Dishley, Leicestershire. Painting by Thomas Weaver, 1810. *London, Tate Gallery*

40

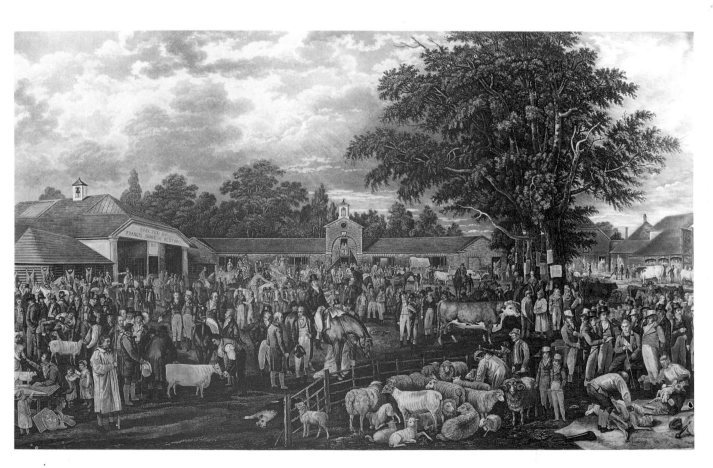

On the right: *Jonas Webb and his Three Rams*. Rams of the Clumber, Liverpool and Woburn breeds. Painted and lithographed in colour by J W Giles. Printed by Hullmandel, 1842. *Rothamsted Library*

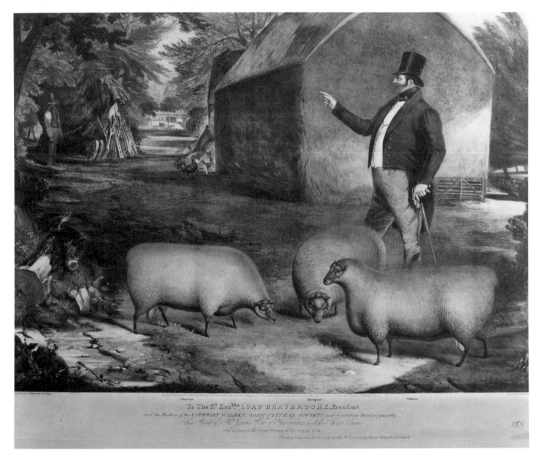

On the right: *Wonder, the Property of Mr William Sherley*. Coloured aquatint by George Hunt after a painting by E.F. Lambert, 1830. *Rothamsted Library*

41

Opposite: *Woburn Sheepshearing*. Forty-eight celebrated agriculturalists are gathered in the farmyard at Woburn Abbey. Engraved by Bate, Sadler, Morris, and Garrard, after a painting by George Garrard, 1811. *Rothamsted Library*

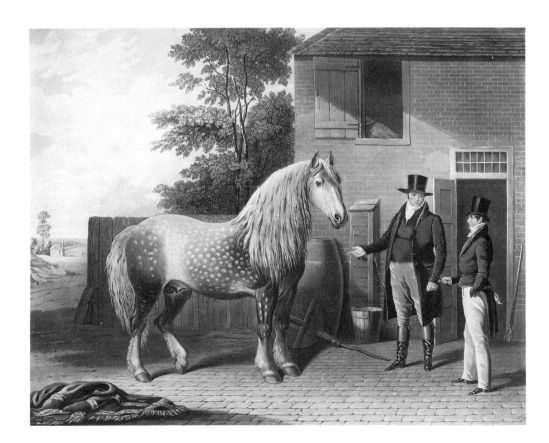

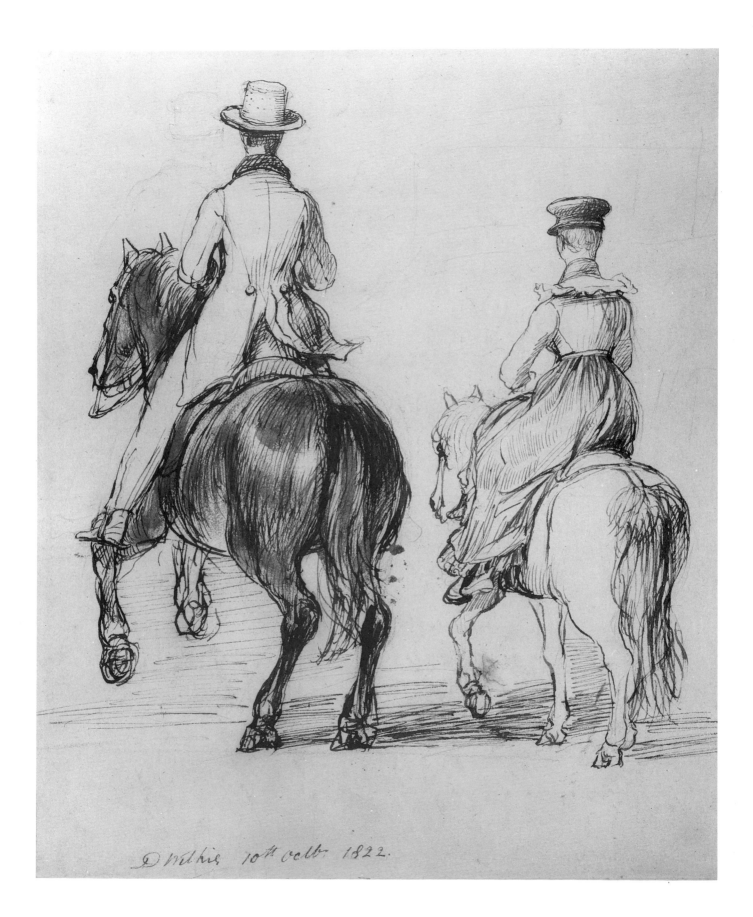

D Wilkie 10th Octr 1822.

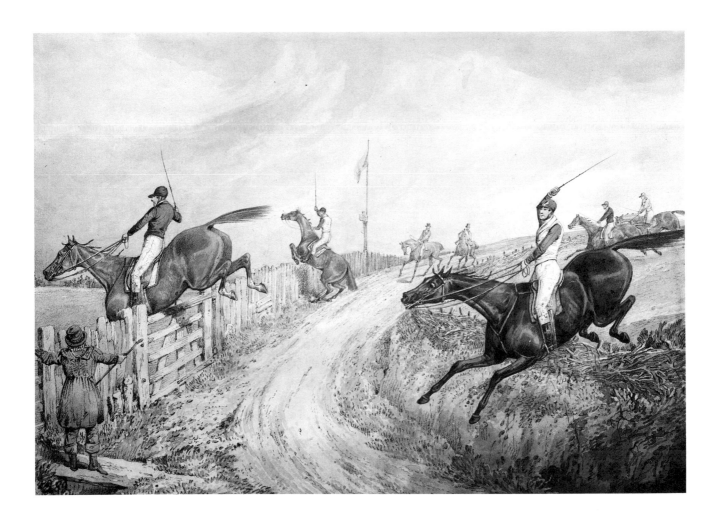

The Field jumping into and out of a Lane. By Henry Alken (1785–1851). Pencil and watercolour. 260 × 365mm. *Paul Mellon Collection, Upperville, Virginia*

43

Opposite: Two riders seen from behind. By Sir David Wilkie, R.A. (1785–1841). Pencil, pen and brown ink, with brown wash. 243 × 198mm; signed and dated 1822. *Paul Mellon Collection, Upperville, Virginia*

As a contrast, or complement, to the somewhat naive treatment of animals illustrated in the foregoing pages I append one or two examples of mainstream animal paintings which I have chosen from those collected by Paul Mellon, who, though an American citizen, had an English mother and was educated partly in England. More than any other collector he established George Stubbs in the main canon of English art of the eighteenth century. Later he focused critical attention on a number of lesser painters of the nineteenth century, whose work had only appealed previously to enthusiasts for field sports. Through his personal evaluation of their artistic merits, and his generous gifts to the Tate Gallery, Yale University and other art galleries, he familiarised the art world with such names as those of Boultbee, Abraham Cooper, Ferneley, Herring and Pollard. For this Mr Mellon was awarded a K.B.E. by the Queen in 1974.

The six paintings or watercolour drawings which I reproduce here are not, like the 'primitives' which precede them, merely portraits of notable beasts, but are – if I may slightly adapt the term – conversation pieces between human beings and their equine friends.

Sir David Wilkie was a Royal Academician, distinguished as a painter of Scottish *genre* and historical scenes. The drawing opposite is so delightfully free and informal that it looks almost like a family sketch – in which, of course, the horses are included.

The steeplechasing scene above is as good an 'action picture' as Henry Alken ever drew or painted, in a composition that brilliantly brings together a

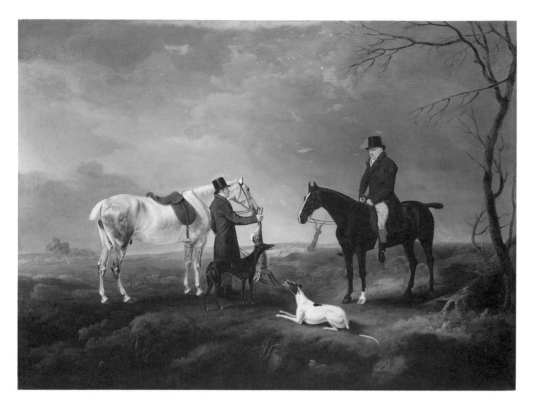

On the left: John Burgess of Clipstone, with his Harriers. Painting by John Ferneley, Senr. 1838.
London, Tate Gallery

group of riders and horses in various stages of motion and elevation.

Perhaps the most gifted of all hunting painters was John Ferneley the elder (1782–1860), who was the son of a wheelwright, and became the pupil of Ben Marshall in London. From 1814 until his death he lived in the heart of the hunting country at Melton Mowbray, where the Quorn, Belvoir and Cottesmore packs provided six days' hunting in a week. Almost all his paintings were commissioned by well-known hunting personalities or racehorse owners. He was a close friend of Charles James Apperley ('Nimrod'). Sir Francis Grant's well-known painting of 'The Melton Hunt Breakfast' shows several of Ferneley's paintings on the walls.

In addition to his carefully posed portraits of his patrons, with their hunt servants, horses and hounds, Ferneley painted a number of wide landscape canvases of hunt scurries across country. An odd characteristic of his horses was the relative smallness of their heads.

Ferneley had two sons who were also sporting artists: Claude Loraine Ferneley and John Ferneley junior.

The conversation piece opposite is one of several that Ferneley painted, including three of his own family, of which one shows the Ferneley family riding, the artist amongst them. The painting of Miss Catherine Herrick with her nieces and nephews was exhibited in the Royal Academy in 1828 as 'Groupe of children, poney and ass'. One of Ferneley's account books records that the Reverend Palmer commissioned it for £42. The children in the painting are the five elder children of the Rev. and Mrs Henry Palmer. Catherine Palmer, who stands on the left of the group, was the children's maternal aunt. A curious feature is that the mounted child, Frederick, aged two, holds a leafy branch as a whip, just as the artist's youngest grandchild does in one of the Ferneley family groups. A pleasant domestic touch is that the eldest boy's trousers are double-tucked above the hem, to allow for them to be let down as he grows taller.

44

Opposite: Miss Catherine Herrick with her Nieces and Nephews, the five elder Children of the Rev. and Mrs Henry Palmer. Painting by John E. Ferneley, Senr. 1827.
Yale Center for British Art, Paul Mellon Collection

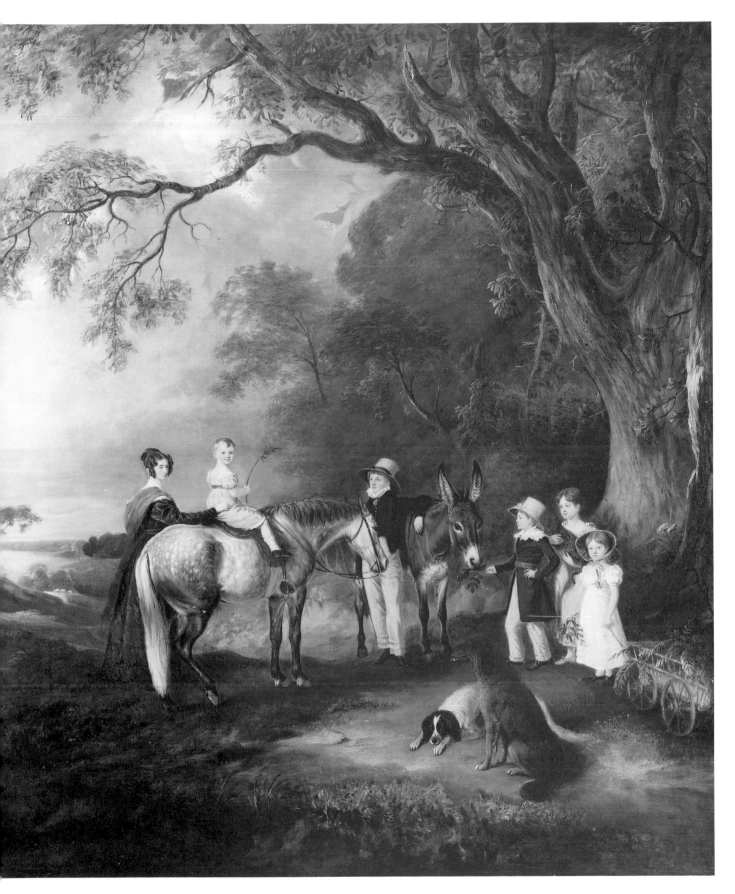

45

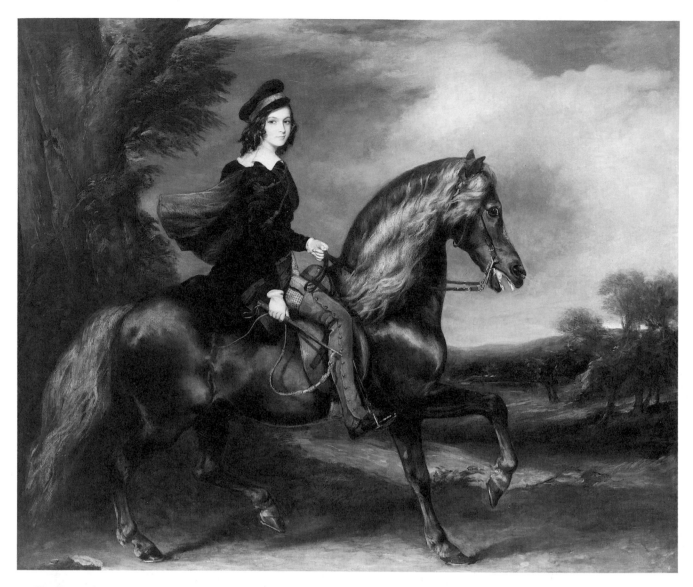

Sir Francis Grant, younger son of a Scottish laird, was one of Ferneley's hunting acquaintances at Melton Mowbray. Having squandered his inheritance he took lessons in painting from Ferneley, and thereafter painted for a living. In due course he became President of the Royal Academy, though Queen Victoria said that he had 'decidedly much talent but it was much the talent of an amateur'. His Sitters' Book, in the National Gallery, London, records that he painted some eight hundred portraits, including one of Queen Victoria.

Master James Keith Fraser, aged eleven when he was painted on his golden chestnut pony, was the third son of one of Wellington's staff officers at Waterloo. The background is wild and hilly, and probably Scottish. Like many of Grant's portraits it has great elegance and style.

The painting opposite is something of a curiosity, having been discovered in Devon in the late nineteen-sixties, not far from where it was painted, with the sitters clearly identified by the inscription on the stretcher but with no indication of the artist's name. It was first attributed, on stylistic grounds, to the Swiss-born painter Jacques-Laurent Agasse, but is now attributed, on the grounds of resemblance, in the rather stiff pose, to an authenticated family portrait of the 9th Earl of Arlie and his daughter aged nine, to a little-known Scottish painter, John Zephaniah Bell (1794–1883).

Master James Keith Fraser on his Pony. Painting by Sir Francis Grant, P.R.A., 1844. Exhibited in the Royal Academy, 1845. *Yale Center for British Art, Paul Mellon Collection*

46

Opposite: John Gubbins Newton and his sister Mary. Painting attributed to John Zephaniah Bell, 1832–33. *Paul Mellon Collection, Upperville, Virginia*

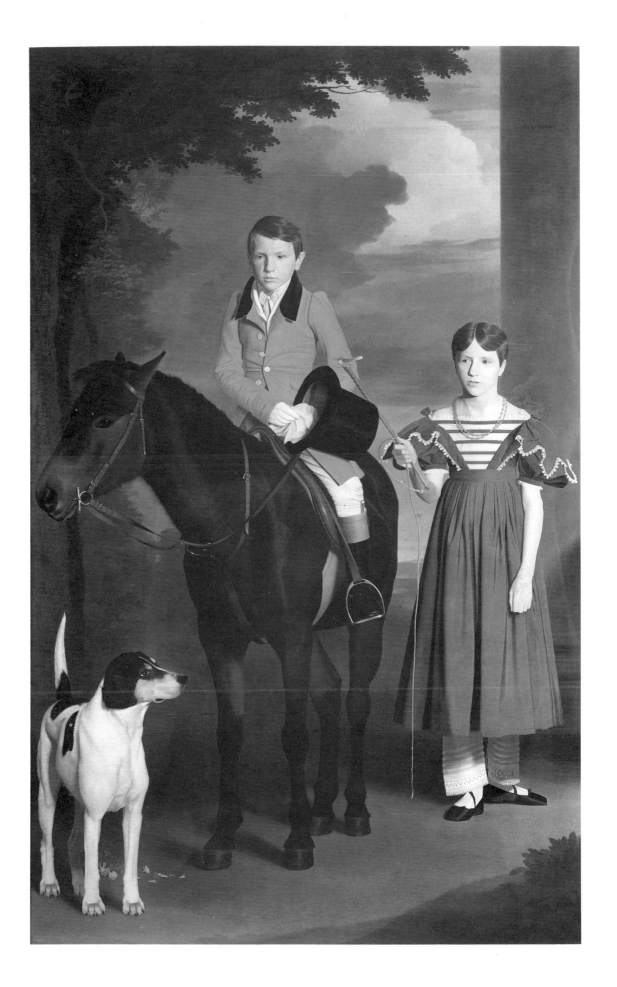

47

XTRAORDINARY HOW POTENT CHEAP MUSIC IS'. So mused Amanda on the balcony in Noël Coward's *Private Lives*. Most people regard that famous generalisation as applying only to the twentieth century – the era of jazz, musical comedies, gramophones, films, swing and pop. Yet I venture to suggest that more sheets of popular music were printed in the reign of Queen Victoria than in the first half of the twentieth century. I do not suggest that either the words or the music in Victorian songs and dance tunes were any better than those of our own time, but there was one feature of them that was markedly superior – namely the illustrations on the covers.

The Victorian song cover could, and often did, reach a higher level of decorative art than many works of so-called 'fine art' of the period.

One reason for this was obviously the skill of the artists. Another, equally important, was the emergence of a new process of illustration, lithography, which was invented in 1797 by Senefelder and was introduced into commercial use in England by Ackermann in 1818. Music publishers took advantage of this invention. Its first use in connection with the cover of a piece of music was in 1840. By 1846 music covers designed by accomplished artists were being produced by an elaborate process involving at least six, and probably seven, printings. Tens of thousands of copies poured from the lithographic stones.

One of the chief artists concerned was John Brandard, who lived from 1812 to 1863, and who might well have become accepted as a conventional landscape artist if he had not been in such demand as a designer of music covers. He worked on many hundreds of covers. George Baxter, well-known as a painter in oils, is the only other artist of note who worked on music covers, especially for titles composed or conducted by the music publisher Antoine Jullien. Most of the designs were executed by artists of whom little otherwise is known. One of the best artists was Thomas Packer, who had a gift for outdoor scenes, flower pieces and foreign views. His work has a certain richness of texture, and was printed by some special process that gave the effect of a granulated surface. But very little is known of his life.

Almost equally unknown until the nineteen-thirties when he was 'discovered' by Sir Sacheverell Sitwell, was Alfred Concanen (1835–86), who was the most outstanding, as he also was one of the most prolific, of the artists of music covers. He came from County Galway to London in the 1860s, and became a habitué of the theatre and music hall. He had a natural gaiety and wit, and a feeling for the grotesque, and his covers give a vivid impression of the social scene in London during the hansom cab era. Few artists of the mid-Victorian period had as keen an eye for 'swells', 'mashers', dandies and men-about-town, with their top hats, their cutaway coats, their kid gloves, their tasselled walking sticks and their eye-glasses. And he was no less exact in the re-creation of the crinolines, shawls and parasols of the ladies of the town.

He had a great facility, too, for portrayal of the music-hall comedians and singers whose popular songs he illustrated, from The Great Vance, Edward Sothern, creator of *The Dundreary Galop*, and George Leybourne, famous as 'Champagne Charlie', down to Arthur Roberts and George Grossmith junior. It should be borne in mind that London had over five hundred music halls in the late Victorian era. There were huge audiences to be entertained, and the entertainers became famous figures.

Concanen's enormous output was achieved partly through his partnership with Thomas Lee, who probably processed Concanen's drawings for the

48

Opposite: *The Music Man*, sung by Howard Paul. Published by Metzler & Co., Great Marlborough Street. The cover, signed by Alfred Concanen, was lithographed by Concanen, Lee and Siebe, at 12 Frith Street, Soho Square. *Collection of Michael Heseltine*

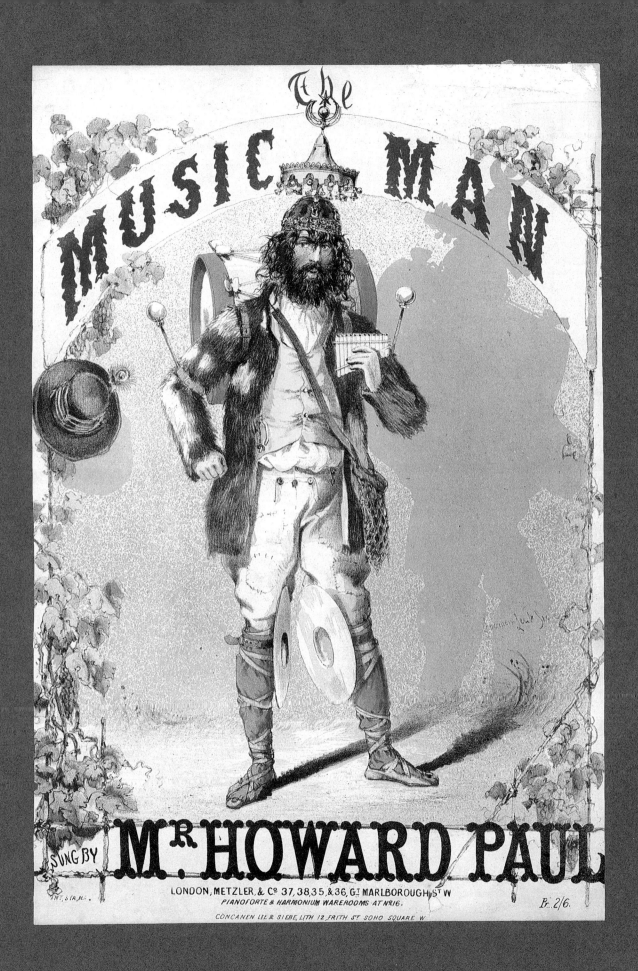

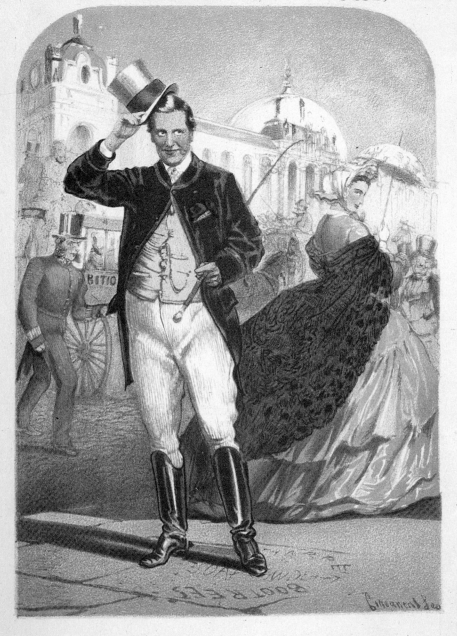

THE DARK GIRL DRESS'D IN BLUE.

An American edition was published by Oliver Ditson in Boston in 1864, without Concanen's cover. The text of the song was substantially altered to appeal to American audiences. Whereas the original verse began with the words 'From a village away in Leicestershire', the American version was altered to 'From a village up the Hudson to New York I came . . .'

press. Many of their music covers are signed 'Concanen and Lee', but the partnership ended in a violent quarrel, for Concanen had a fiery Irish temper, though he was immensely popular in theatrical circles.

A word should be said of the printers who were responsible for the vast output of music covers. Probably the number of copies of each title produced at each printing did not exceed two thousand, and the selling price was usually four shillings. Even allowing for the vast difference in money values today the margin of profit cannot have been high, and the fees paid to artists were low. But the total output was so great that the artists never lacked for work.

Probably the outstanding firm of lithographers was M. & N. Hanhart, who

On the right: *I'm the Dark Girl dressed in Blue*. Written by Watkin Williams. Sung by Kate Harley. Published by B. Williams, Paternoster Row, London (1863). Cover signed by Alfred Concanen and lithographed by Concanen and Lee. *The British Library, London*

The British Library also has a 'Companion Song' entitled *The Dark Man dress'd in Blue*, also written by Watkin Williams, and published by B. Williams, with a cover by Concanen. The song discloses that the man in question was a confidence trickster, and the Dark Girl found him operating in a fraudulent auction room.

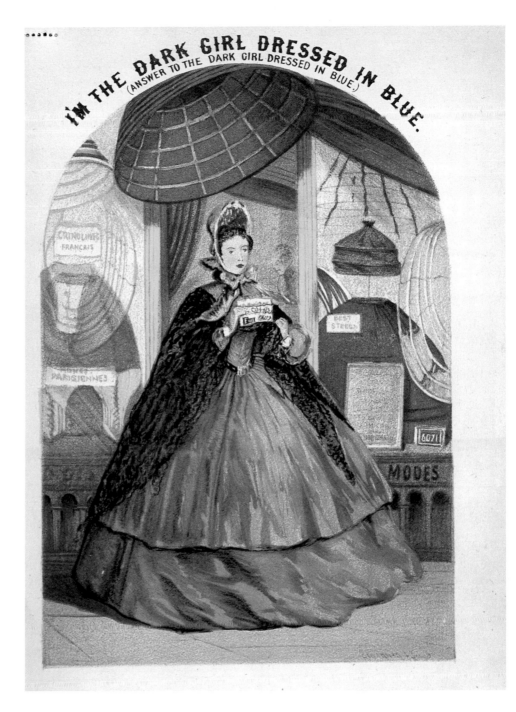

also printed lithographic plates for Philip Gosse's zoological books. They obviously had very high standards, as is evident from the topographical covers they printed for John Brandard. It is believed that Thomas Packer was a printer as well as an artist, but many of his covers, as also those of Concanen, were printed by Stannard & Dixon. Another artist who was also to some extent a printer was S. Rosenthal, who had a gift for vigorous figure drawing. He also worked on Ruskin's drawings for his *Stones of Venice*.

At the end of the century chromolithography became largely mechanized through use of photography, and standards fell sharply, but during the middle of the century some of the London colour printers were the best in Europe, and the music covers designed by Brandard, Concanen, Packer and Rosenthal are collectors' pieces to be treasured today.

SAY YES.

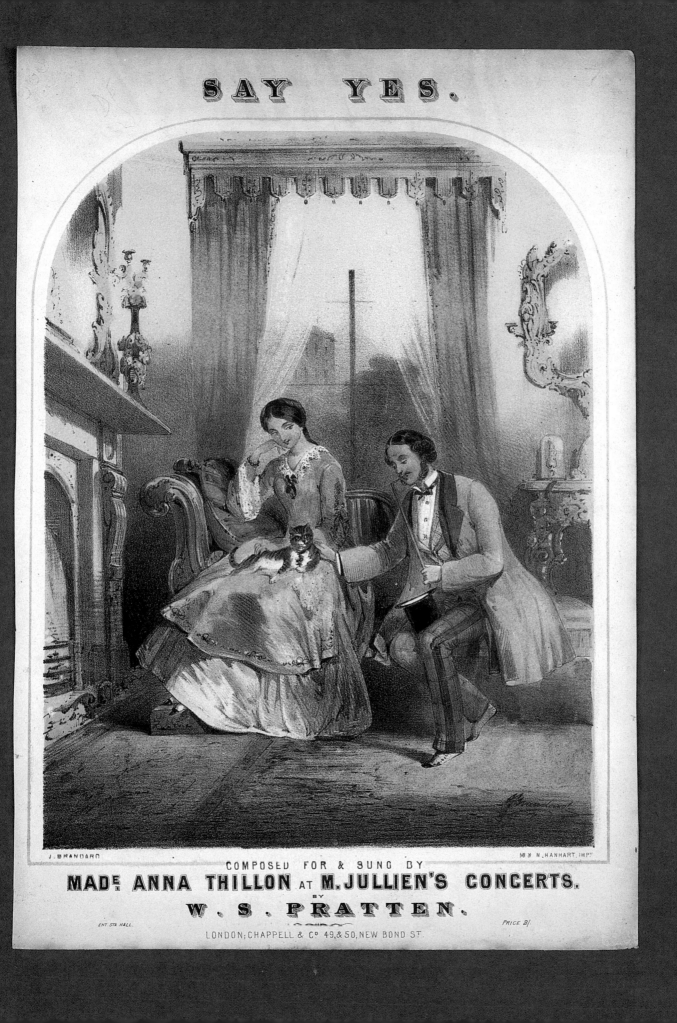

COMPOSED FOR & SUNG BY

MADE. ANNA THILLON AT M. JULLIEN'S CONCERTS.

BY

W. S. PRATTEN.

ENT. STA. HALL. Price 2/

LONDON; CHAPPELL & Cº 49, & 50, NEW BOND ST.

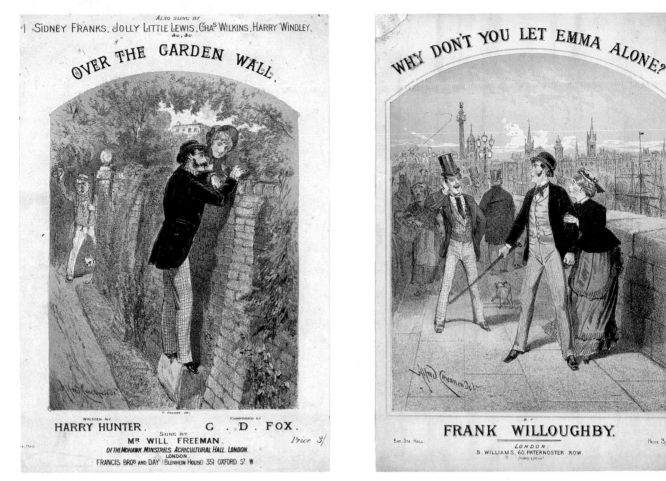

OVER THE GARDEN WALL.

T. PACKER INF.

WRITTEN BY
HARRY HUNTER.
COMPOSED BY
G. D. FOX.

SUNG BY
MR WILL FREEMAN.
OF THE MOHAWK MINSTRELS. AGRICULTURAL HALL. LONDON.
LONDON.
FRANCIS BROS AND DAY (BLENHEIM HOUSE) 351 OXFORD ST W

Price 3/

WHY DON'T YOU LET EMMA ALONE?

BY
FRANK WILLOUGHBY.

ENT. STA HALL.

LONDON;
B. WILLIAMS, 60, PATERNOSTER ROW.

Price 3/-

53

Although John Brandard, who designed the cover opposite, is known chiefly for landscape subjects, he could turn his hand very successfully to interior scenes. When he did so his domestic details, such as curtains, furniture and fireplaces, were always drawn with meticulous accuracy. The lady's crinoline illustrated here dates the cover before 1868, by which time the crinoline had given way to the bustle. It is said that the reason for this change in fashion was the advent of the hansom-cab. The smart lady would have had difficulties in mounting, let alone disposing of a crinoline, in so constricted a conveyance. *Author's Collection*

Above are two characteristic examples of lithographic covers drawn by Alfred Concanen. *Over the Garden Wall* was a song much whistled by errand boys in London streets in the later years of Victoria's reign, and the acknowledgements given to the performers on the cover indicate how popular it was on 'the Halls' as well as in the shows put on by the Mohawk Minstrels. Clandestine courtship over garden walls seemed to have a special appeal to the Victorians, as is evidenced by the well-known paintings, 'Broken Vows' by Calderon, in the Tate Gallery, and 'The Tryst' by Frank Stone. The author and composer of 'Over the Garden Wall' wrote another hit called 'Under the Chestnut Tree' which also had a cover designed by Concanen. It is interesting that the cover of 'Over the Garden Wall', though signed by Concanen, was printed by another cover artist, Thomas Packer.

The scene of *Why don't you leave Emma alone?* is recognisable as the London Embankment, with the Monument in the background. I was puzzled when I first saw this cover as to whether the angry gentleman with the top hat was the young woman's husband, father or *fiancé*. The words of the song suggest a quite different situation. Apparently a current song contained the catch phrase 'Whoa Emma!' The song writer assumed this to be the actual name of the lady who had been 'billing and cooing' with the gentleman in the yellow waistcoat. Hearing the phrase called out by someone in the crowd her sweetheart's jealousy was fired and he turned to strike the imagined rival. A somewhat tortuous theme for a popular song! But charmingly portrayed by Concanen.

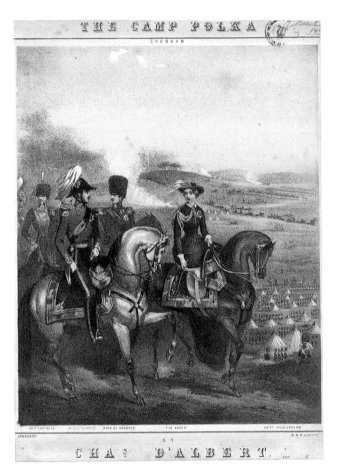

THE CAMP POLKA

CHOBHAM

CHA? D'ALBERT.

The cover for *The Camp Polka*, reproduced on the left is an example of what might be called 'pictorial journalism' of the period. Designed by John Brandard for a polka written by Charles d'Albert, it was published in 1853 when British forces were encamped at Chobham, in Surrey, in readiness for embarkation for the Crimean War. The figures following Queen Victoria are the King of Hanover, Prince Albert and Lord Carnarvon. One of many music covers by John Brandard printed by M. & N. Hanhart.
Author's Collection

Opposite: *Jullien's American Polka*. Designed by John Brandard, who specialized in covers for dances, operas and stage scenes. He designed a number of covers for dance music composed by Louis Antoine Jullien (1812–60), a conductor who came from France in 1830 to put on a series of promenande concerts featuring his immensely popular 'Monster Quadrilles'. Jullien repeated his successes in the United States, but became bankrupt, returned to Paris, was arrested for debt, and died insane. Brandard's music covers frequently presented the most prominent dancers as idealised versions of Queen Victoria and Prince Albert.
Author's Collection

On the right is a cover produced to celebrate the wedding of the Prince of Wales to Princess Alexandra in 1863. The song was composed and arranged for the pianoforte by Brinley Richards and had become something of a Welsh national anthem shortly after it was written in 1862. In the British Library there are over thirty-five printed versions of it, written for choirs, schools and orchestras. The wedding took place in St George's Chapel, Windsor. The window illustrated in the cover design was altered by Queen Victoria in 1863 as a memorial to Prince Albert. This cover was designed by Thomas Packer and printed by Stannard & Dixon.
Author's Collection

54

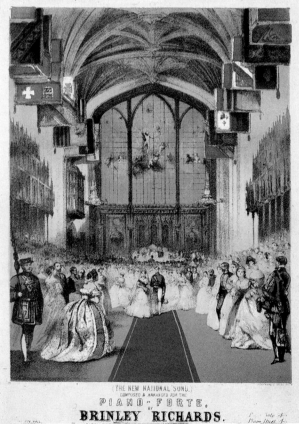

GOD BLESS THE PRINCE OF WALES.

(THE NEW NATIONAL SONG.)
COMPOSED & ARRANGED FOR THE
PIANO-FORTE,
BY
BRINLEY RICHARDS.

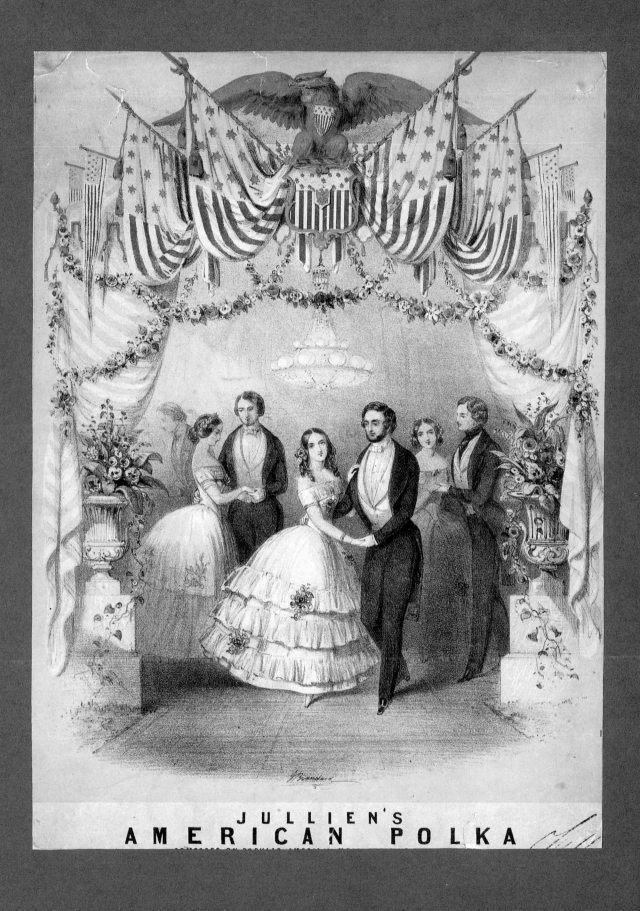

JULLIEN'S
AMERICAN POLKA

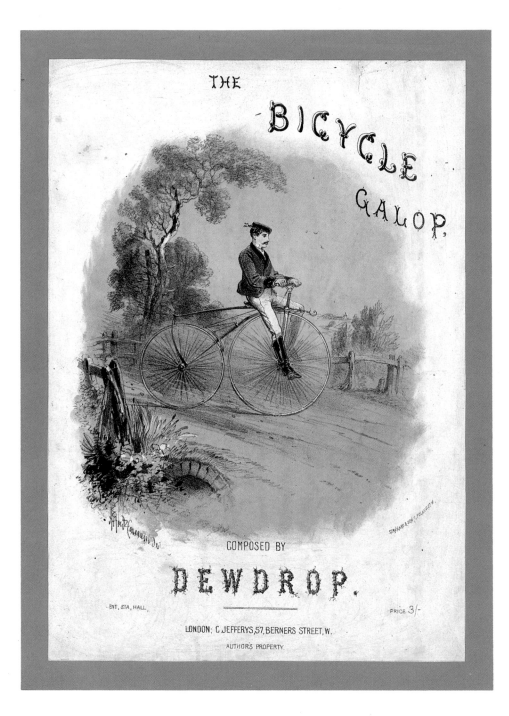

The Bicycle Galop, composed by Dewdrop, the cover designed by Alfred Concanen. The penny-farthing or boneshaker bicycle was introduced about 1870 and remained popular until the mid-nineties. Who was 'Dewdrop'? All I can discover about him is that, under the same pseudonym, he composed *Claudine Waltzes, The Apple Blossom Waltz* and a polka called *Euphrosyne* in 1869, *The Tudor Quadrille* in 1871, and *Bright Hours Waltz* in 1876. I fancy that he was an amateur song writer who, judging by the printed statement that *The Bicycle Galop* was 'Author's Property', had his music printed at his own expense.
Author's Collection

For a minor art so prolific there is an extraordinary lack of critical literature. In 1948 Sacheverell Sitwell published *Morning, Noon and Night in London,* an indiosyncratic appreciation of the work of Concanen. Later, Mr Hyatt King, Assistant Keeper of Music in the British Museum, contributed a well-researched study of five of the leading cover artists to the 1952 issue of *The Penrose Annual*; but the most substantial book I have come across is *Victorian Sheet Music Covers* by Ronald Pearsall (David & Charles, 1972). There was also one written by Doreen and Sidney Spellman, and published by Evelyn, Adams and Mackay in 1969.

So many of these music covers were produced that hundreds of copies still survive, and can be bought for relatively small cost.

The covers on this page, for *Spring Morn* (top left), *Summer Noon* (top right), *Autumn Eve* (bottom right) and *Winter Night* (bottom left) are for a series of four songs of the seasons, the 'poems' by

J.E. Carpenter with music by Stephen Glover. All were designed by John Brandard. What would original Victorian watercolours of this quality fetch in the auction room today? *Author's Collection*

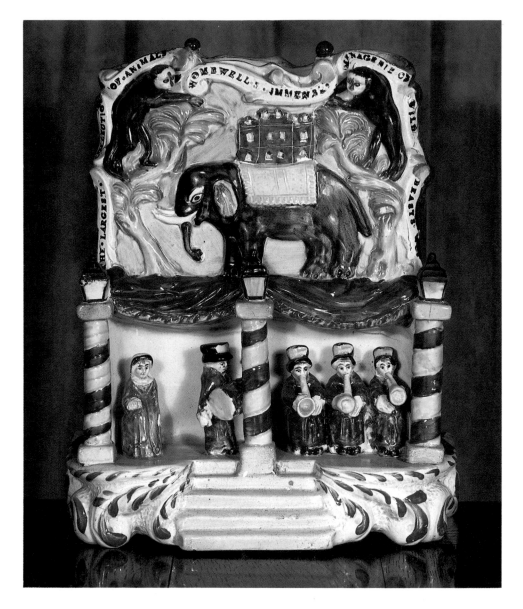

NDER THIS HEADING I am not including Pratt Ware, although it was produced by several potters in Staffordshire and the North of England until the mid-eighteen-thirties. It originated, however, in the seventeen-eighties, and, distinctive though Pratt jugs are, their decorative elements derive largely from conventions of the eighteenth century, as also do most of the personalities and events which the jugs commemorate.

I am excluding, too, the quaint Astbury-Whieldon soldiers, musicians and horsemen, which date from the mid-eighteenth century (apart from the reproductions made during and after the First World War), and also the elegant figures supposed to have been modelled in the late eighteenth century by John Voyez for Ralph Wood, and the Toby jugs and mythological figures for which the Wood family were responsible.

With the coming of the nineteenth century a less sophisticated school of potters appeared on the scene in Burslem and Hanley, producing a great variety of small and simple human figures, occasionally representing Biblical characters, but for the most part based upon the rural English community.

58

Above: *Wombwell's Menagerie of Wild Beasts.* Decorated in enamel colours. Probably made by Obadiah Sherratt at Burslem, c.1830. *Cambridge, Fitzwilliam Museum.* There are other versions of this group, very similar but headed *Polito's Menagerie.*

On the right: *Flight to Egypt*, one of a pair of enamel-decorated figures, marked on the back, WALTON. The other is lettered on the base *Return from Egypt.* c.1820. *Collection, Dr Patrick Hadfield*

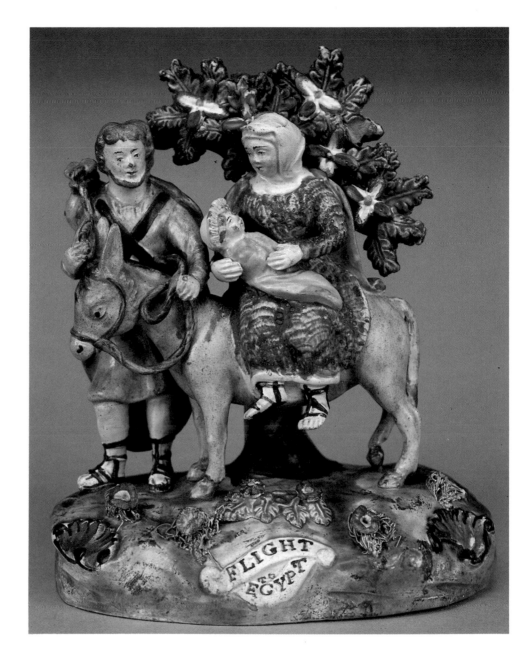

Some of these potters identified their work with such names as Walton, Salt or Tittensor, stamped in scrolls on the bases or backs of their figures; but I personally have never (nor has anyone else to my knowledge) seen a figure marked with the name of one of the most individual of these potters, Obadiah Sherratt, to whom are attributed some vigorous models of circus animals, cock-fighting and bull-baiting scenes, and a marriage ceremony at Gretna Green. All of these are decorated in strong enamel colours. Some of the pieces are only identifiable as Sherratt's work by their rococo stands, with swags of flowers on the front.

Sherratt was recorded as being a Master Potter at Sneyd Green, Burslem, in 1815, and again at Waterloo Road. It seems that he was illiterate, signing his name, as also did his wife, with a cross in the marriage register. And some of his figure groups had their titles misspelt.

The assumption is that most of the products of John Walton (c.1815–1835), Ralph Salt (c.1828–1840), Charles Tittensor (c.1818–1823) and Obadiah Sher-

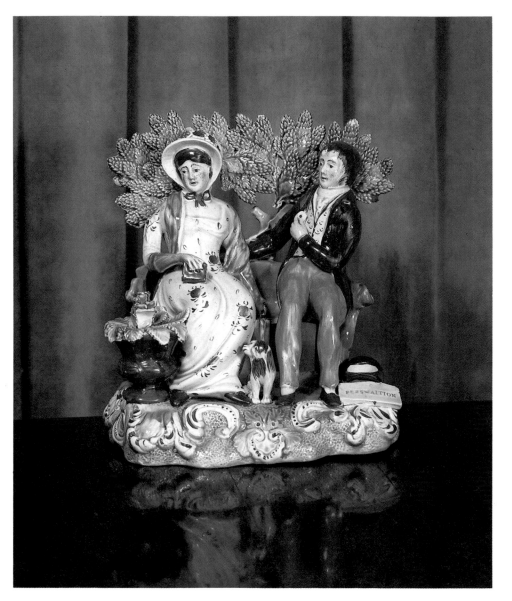

Perswaition (sic). A group probably made by John Walton, as the base and the bocage are characteristic of his work. Decorated in enamel colours. There are other examples of this model in which the ill-spelt title is replaced by the gentleman's hat. c.1820 *Cambridge, Fitzwilliam Museum*

ratt (c.1815–1830), were marketed in country districts to farmers and tradesmen as chimneypiece decorations for cottages and farmhouses. The Walton and Salt pieces are the ones most frequently marked, and can usually be identified by their backgrounds of leafy *bocage* and flowers. Walton, more often than others in this group, liked to attempt biblical subjects, such as 'Flight to Egypt' and 'Return from Egypt', which are two of his most polished and ambitious efforts. To him also are probably to be attributed an amusing series of domestic cameos of courtship, a marriage at Gretna Green, and a husband and wife quarrelling. The 'Tee Total' group is sometimes taken as being one of this series, but its rococo stand suggests the so-called Obadiah Sherratt group. It should be borne in mind that these potters, working in a naive convention for an unsophisticated market, did not hesitate to copy one another's models.

Several members of the Tittensor family are recorded as living and working in Stoke, Hanley, Fenton and Shelton between 1780 and 1823, some of them working rather in the Pratt convention. There is a charming small figure of a seated boy, wearing trousers and reading, which has the impressed mark

Tee Total, a group painted with enamel colours. Despite a general similarity with the Walton domestic group, the shape of the base suggests that this was made by Obadiah Sherratt of Burslem. c.1820. 197mm high. *Cambridge, Fitzwilliam Museum*

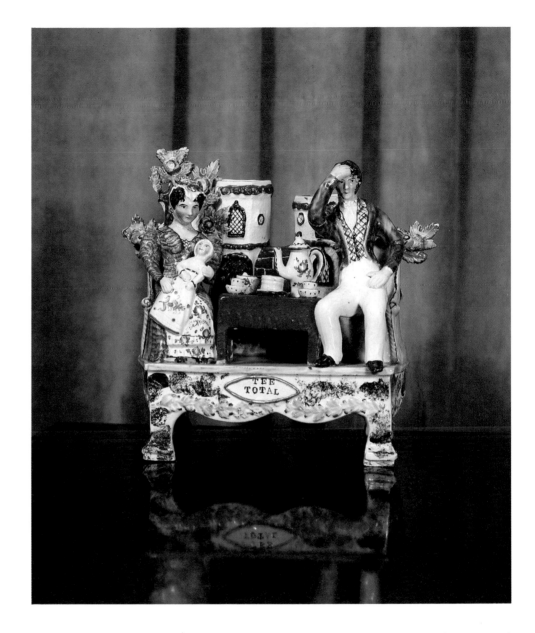

TITTENSOR in capitals on the back of the green-washed base. This is assumed to have been the work of Charles Tittensor who was potting at Shelton from 1818 to 1823, as also is the very rare piece illustrated on page 62.

There is another group of chimneypiece pottery of which large numbers were produced in the last years of the eighteenth century and the earlier years of the nineteenth century, and that is cow creamers, usually about 150 millimetres high, standing on a roughly rectangular base, decorated in underglaze mottled colouring in the earlier models, and often with a seated milkmaid or a standing herdsman beside the cow. They were very rarely marked, and they seem to have been made as much in Yorkshire as in Staffordshire. The late Captain C.B. Kidd, of Sherbourne, a sometime Master of the Warwickshire Hunt, amassed a huge collection of these, almost all different. There is also the Keiller Collection in the Stoke-on-Trent Museum, where over four thousand cow creamers are on view.

Another popular product was the earthenware cottage, produced in large numbers in Staffordshire in the mid-Victorian period and much later. They were usually decorated in enamel colours, with applied strands of clay to

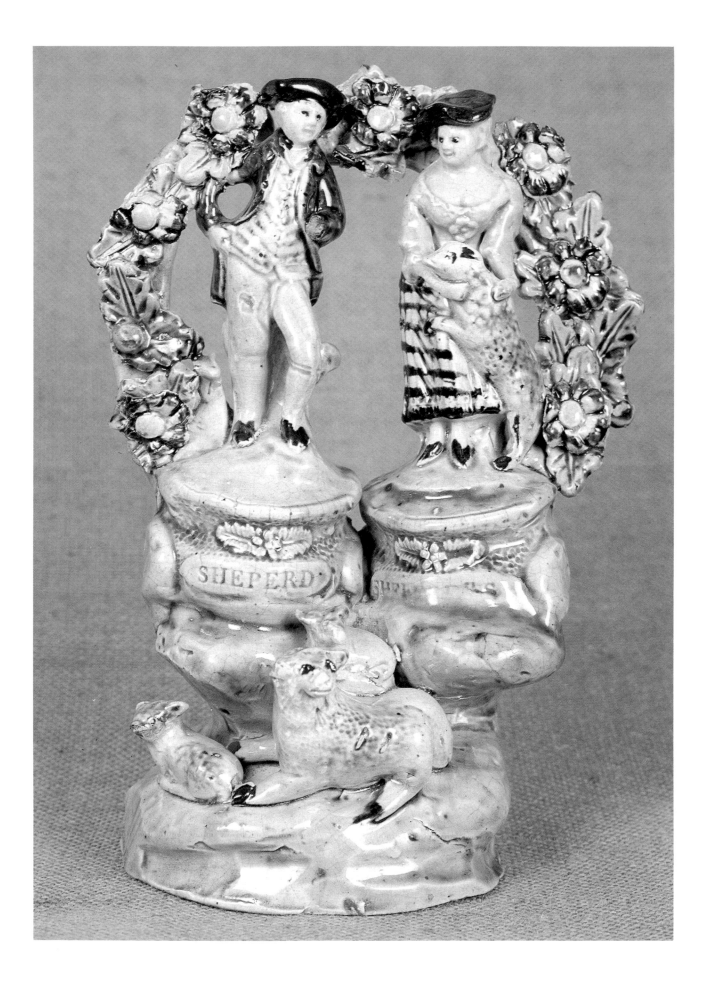

Opposite: *Sheperd* (sic). A rare group by Charles Tittensor, in underglaze colouring, with the name TITTENSOR impressed on the back in three places. c.1820. 215mm high. *Alistair Sampson Antiques.*

The marking in triplicate may perhaps be due to the group having been assembled from three, if not four, separate moulds: one for each of the two figures on its own circular stand, one for the larger base supporting the sheep, and another for the bocage linking the figures. Three of these separate moulds evidently bore the potter's imprint.

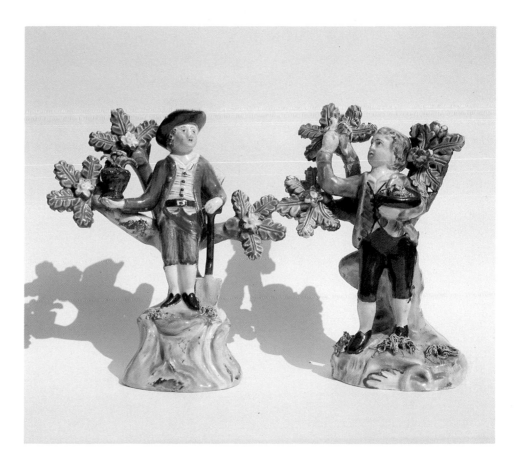

On the right, above: A pair of rustic figures probably gardeners, painted in enamel colours, attributed to John Walton. c.1820. *Private Collection*

63

On the right, below: *Gardners* (sic). A pair of figures decorated in enamel colours, impressed SALT on a scroll on the back of the rocky base. c.1830. 155mm high. *Private Collection*

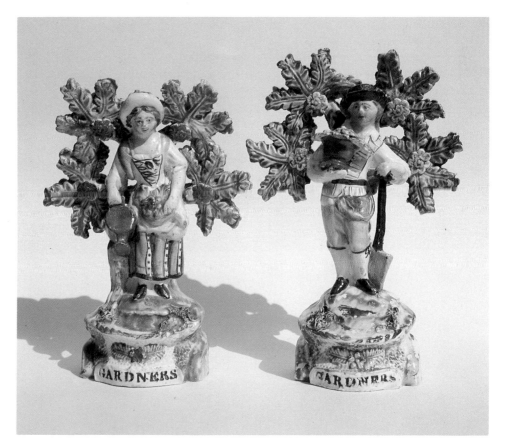

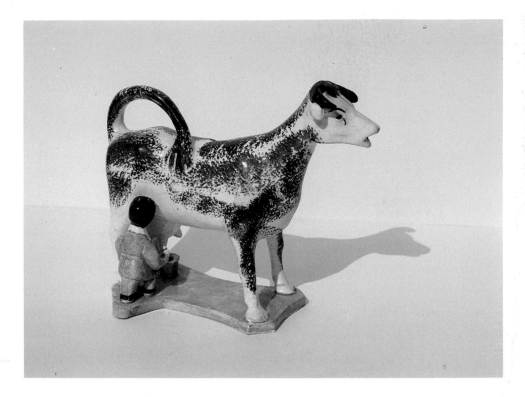

simulate greenery and flowers. They are interesting architecturally – some are in the form of castles – and are delightfully decorative in a naive manner. Sometimes they served as pastile burners, with an opening at the back in which the pastile was placed, and with hollow chimneys to convey the scent. Some continued to be made from the original moulds until recently, and should be bought with care.

As I indicated in my introduction, these pottery chimneypiece ornaments, with their amusing combination of sentiment and humour, are as faithful a reflection of the social life of rural England in the nineteenth century as the fashion plates are of the life of the well-to-do and Concanen's music titles are of Bond Street and the Music Halls.

64

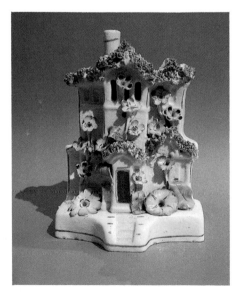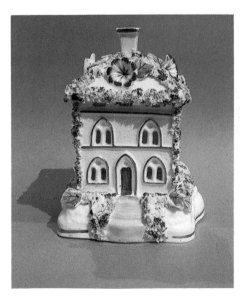

Left: a white earthenware
pastille burner, decorated
in enamel colours with
extruded strands simulating
greenery and flowers.
110mm high. The cottage
is removable from the base.
Made in Staffordshire,
c.1830–40. *Collection,
Mrs John Hadfield*
Far left: a Staffordshire
white earthenware cottage
(not a pastile burner),
decorated in enamel
colours, with an abundance
of superimposed flowers.
130mm high. c.1830–40.
*Collection, Mrs John
Hadfield*

PORTRAITS IN POTTERY

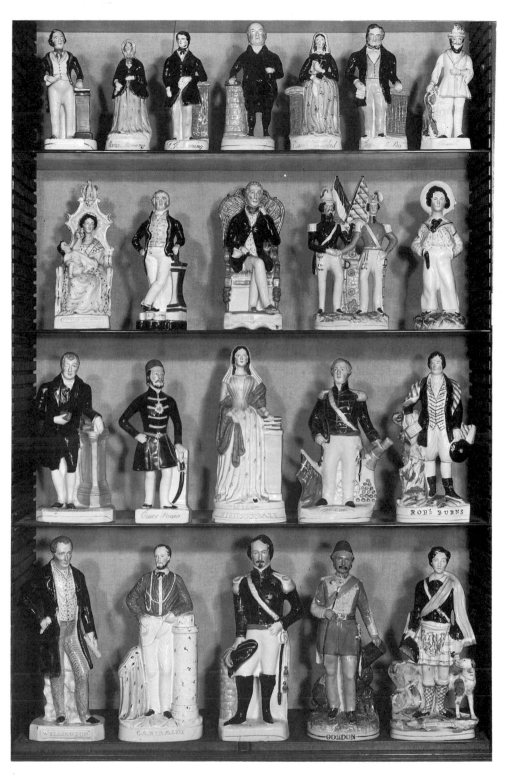

A group of Staffordshire pottery portrait figures in Thomas Balston's Collection, photographed by Edwin Smith

HERE WAS A PERIOD in the mid-nineteenth century when the market was flooded with pottery portrait figures, mostly white but with some gold and enamel decorations, usually standing upright, and usually with flat backs. These are not as rare as the more distinctive figures of earlier years, and as a result they remain the chief stock-in-trade of antique dealers today. Two large collections of them were made in recent years, by Thomas Balston and Admiral Gordon Pugh. The former was bequeathed to the National

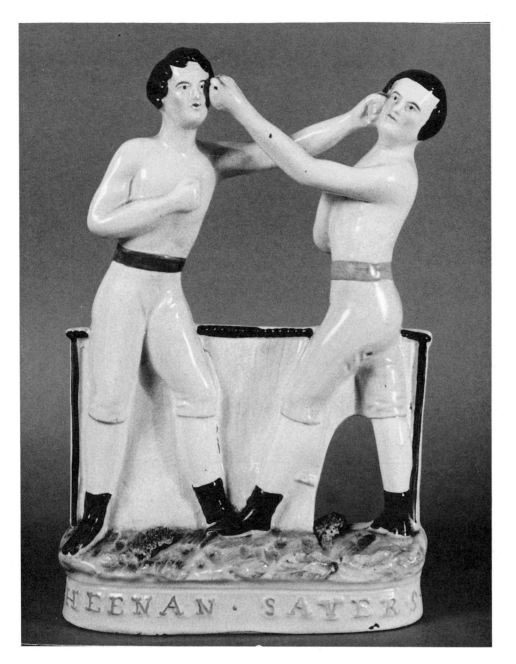

Staffordshire portrait group. Heenan versus Sayers. 247mm high. 1860. John Carmel Heenan, born in New York in 1835, became a London bricklayer, and on 17 April 1860 fought Tom Sayers before 12,000 spectators in Farnborough. He was knocked down repeatedly, but in the thirty-seventh round the referees declared a draw.

Trust and is now to be seen at Bantock House in Wolverhampton. Most of Admiral Pugh's collection is now in the Museum at Stoke-on-Trent. Both of these collectors wrote books about their collections, and a revised catalogue of the Pugh Collection has been published by the Antique Collectors Club.

These flat-back portrait figures lack the individuality of the more varied earlier pottery figures, but they have a special historical interest as usually carrying the names of the personalities they depict.

Apart from the Royal Family they celebrate a variety of politicians, generals, actors and other public figures such as Garibaldi, Abraham Lincoln and Florence Nightingale. The highwaymen Dick Turpin and Tom King are commemorated; the murderer James Rush is appropriately sinister; and several fictitious characters such as Uncle Tom and Little Eva appear. In the same vein were anonymous sailors, highlanders, shepherdesses and lovers, often produced as flower holders or watch-stands.

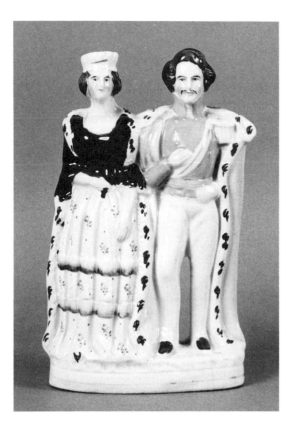

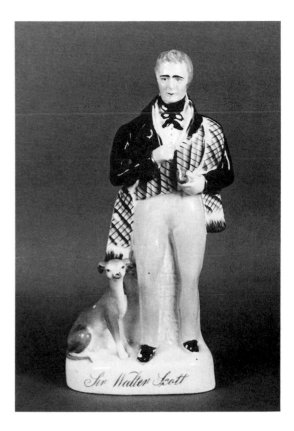

Above: Victoria and Albert 184mm high
Below: Lord Shaftesbury. c.1848.
 190mm high

Above: Sir Walter Scott. 390mm high
Below: The Prince of Wales. c.1848.
 300mm high

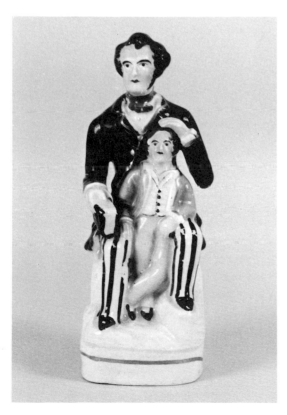

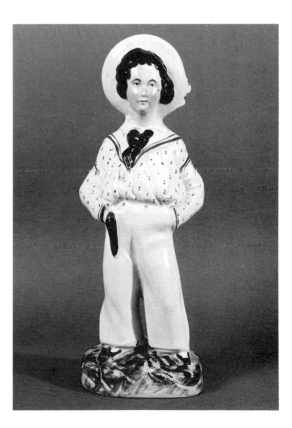

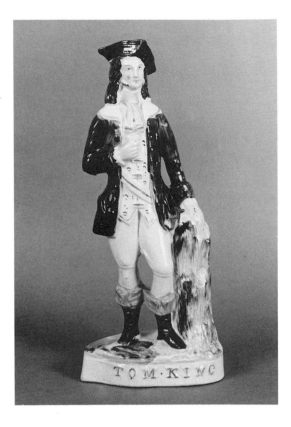

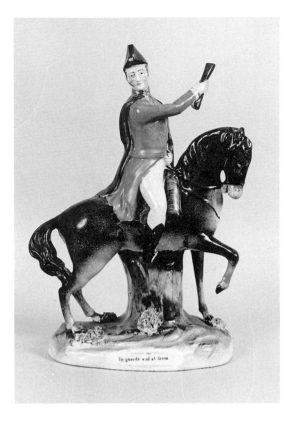

Above: Tom King, Highwayman. 265 mm high
Below: Charles Stewart Parnell, 183mm high

Above: The Duke of Wellington. 295mm high
Below: Garibaldi at Home, 1864. 240mm high

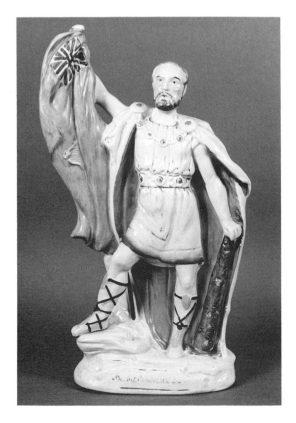

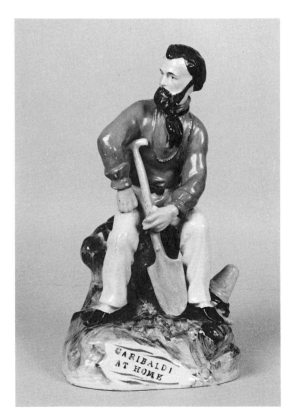

68

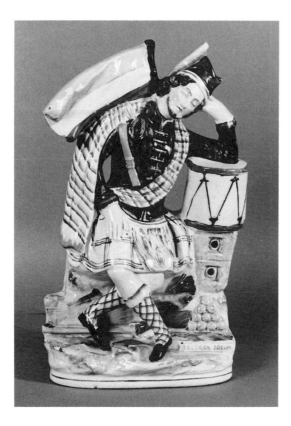

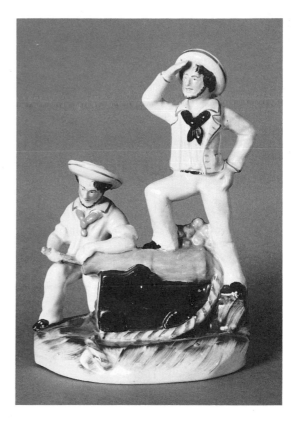

Above: Soldier's Dream. 320mm high.
 1854–56
Below: Burns with Highland Mary,
 273mm high

Above: Soldiers Loading a Gun, 254mm high.
 1854–56
Below: Grapplers. 294mm high
 A Scandinavian form of wrestling

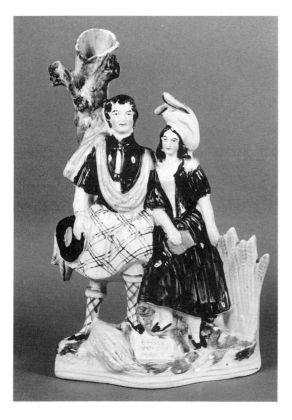

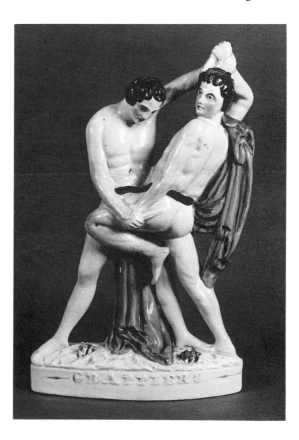

I N CONTRAST to what the French artists and engravers of the fashion plate were doing to enhance the beauty of women by means of the newly invented process of lithography, Americans were endeavouring to achieve the same end by means of developments in the technique of photography.

The pin-up portrait is commonly regarded as a product of the twentieth century, achieving a wide circulation through the tabloid newspapers and popular magazines that sprang into being in the age of Hearst and Harmsworth. In fact the pin-up was the product of some go-ahead photographic studios in New York as early as the eighteen-sixties.

For some twenty years previously women had been patronising the studios where, with a few seconds exposure, a small photographic *carte-de-visite* could be produced. The half-tone printing process had not yet arrived, to supersede illustration by wood-engravings; and the photographic portrait was still a novelty. The props required were no more than an easy chair with an antimacassar draped over it, a background curtain, and perhaps an aspidistra on a stand to provide a decorative element.

As the cliché had it, 'the camera cannot lie'. But it could glamorise. In the 'seventies photographic lenses became sharper, plates were exposed faster, and lighting techniques were improved. Moreover, the art of retouching was developed, removing lines and wrinkles from the sitters' faces. In order to make this financially worthwhile, what were called 'Cabinet' photographs had come into use in 1866. They were larger than the little *cartes-de-visite*, and were mounted on decorative cards measuring $6\frac{1}{2}$ by $4\frac{1}{2}$ inches.

The new-style photographic portraiture obviously appealed to actresses, who flocked to the studios. In the United States the 'burlesque' theatre was coming into being. In 1869 a musical revue with the title of *British Blondes* set New York alight. Its appeal chiefly derived from the physical charms of four British beauties: Pauline Markham, Ada Harley, Lisa Weber and Lydia Thompson. Miss Markham especially was courted by the 'mashers' – known in New York as 'spoons' – who begged for photographs if they were unable to obtain the more traditional favours.

There was keen competition amongst the studios for sittings by the chief glamour girls; and the leading actresses could demand high fees for an afternoon in the studio. It was not enough to be 'a peach' or have a well-rounded thigh. The dressmakers were soon on the scene, and the latest cabinet photographs were seized and scrutinised for new fashion trends. Intricate coiffeurs were surmounted by wide-brimmed hats trimmed with flowers and stuffed birds.

As has happened throughout modern times, even the most outrageous fashions quickly spread upwards through the social strata. And in New York, Boston and Chicago the leading photographers soon became arbiters of fashion, as well as publicity agents for the stars. Amongst the best known, who could command the top prices, were Napoleon Sarony, Jose Maria Mora and Joseph Falk.

There were, of course, competitors in Europe, such as Bassano, Downey, and Elliott & Fry in London, and in France the famous Nadar. But such was the reputation of the New York photographers that Paris studios bought American negatives and credited the prints as 'Photographie Americaine'.

The cabinet photographs reproduced here date from the period between 1870 and 1900, and come from the famous collection of Mr Philip Kaplan in Long Island, to whom the author is indebted not only for the loan of the original sepia prints but also for much information about the sitters.

Pauline Markham,
Englargement of a
cabinet photograph
by Napoleon Sarony.
c.1870

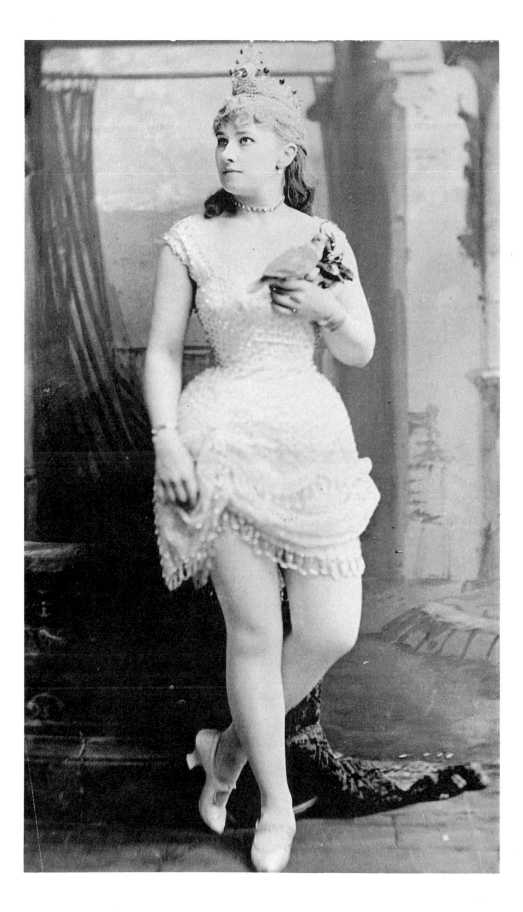

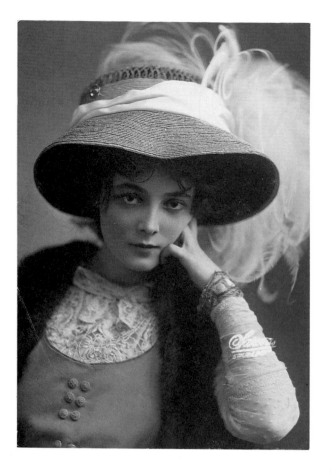

SARONY

Napoleon Sarony, who was born in Quebec in 1821, the son of German parents, was not only a pioneer of what become known as glamour photography, but was also himself something of a showman. Only five feet tall, usually wearing an Astrakhan jacket, with his trousers tucked into polished Hessian boots, he wore a Turkish fez. He had worked as a photographer with his brother Otto in London, and opened his first

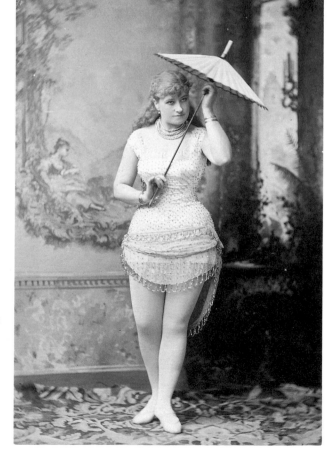

Above is a photograph by Sarony that would qualify on a high aesthetic level for inclusion amongst the outstanding portraits of the period. The sitter is Marie Doro, who was one of the earliest movie stars; and Mr Kaplan dates this photograph around 1900. On the right is Sarony's portrait of Pauline Markham as Robinson Crusoe in pantomine. She was one of the four stars of the revue *British Blondes* which made such a hit in New York in 1869. One critic wrote to her that 'she comes as near a personal realisation of the goddess of loveliness as one can expect.'

studio in New York in 1864. He later moved to a
larger studio in Union Square, which he filled with
bizarre props, including Egyptian mummies, stuffed
birds, a Russian sleigh and medieval instruments of
torture. He left the handling of the camera to an
assistant, whilst he posed his sitters, and made them
play to the camera as though to a live audience. By
1880 he had amassed over forty thousand negatives,
not only of actresses, but of politicians, prize-fighters,
religious figures and circus characters. He died in 1896.

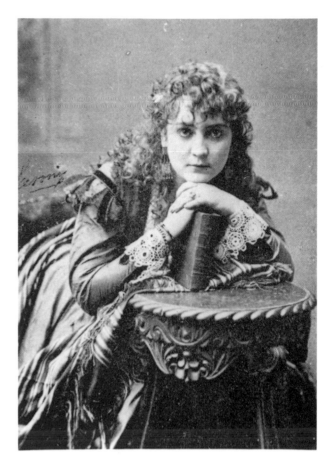

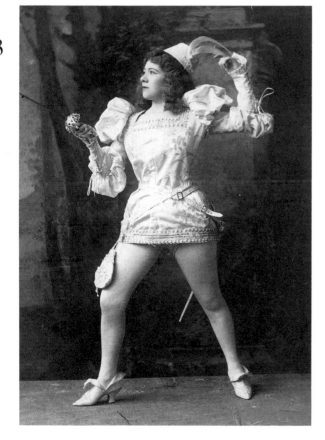

73

Above is Sarony's portrait of the American actress
and poetess, Adah Isaacs Menken. Although she died
in 1868 at the age of thirty-three, she had by then been
married at least four times, once to John Carmel
Heenan (1835–73), a London bricklayer who became
a boxer and won the Champion's Belt in 1857. In 1864
Adah Menken appeared with great success in London
in *Mazeppa*. Among her friends were the elder Dumas,
Dickens and Swinburne, whose poem 'Dolores'
addressed to 'Our Lady of Pain', was inspired by her.
On the left is Sarony's photograph of Marie Tempest,
aged twenty-six, in *The Fencing Master*, a photograph
taken in 1892.

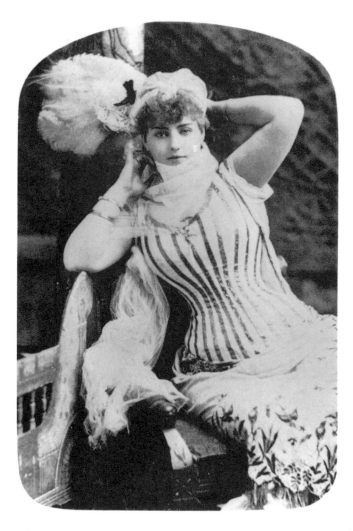

MORA

Sarony's chief competitor was José Maria Mora, son of a wealthy Cuban planter, who had gone to Europe to study art, but became interested in photography. In 1869, after a revolution in Cuba, he came to New York and became assistant to Sarony. Whilst still in his 'twenties he set up on his own, specialising in portraits of actresses whom he got to know as a regular first-nighter in the New York theatres. On the left is Mora's skilfully posed study of Lillian Russell, in the *The Snake Charmer*. He went in for very elaborate settings including *papier-maché* rocks, gilt fireplaces

74

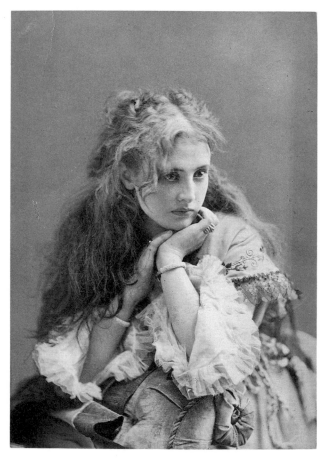

HOWELL

Howell was one of Mora's chief competitors in New York, along with Gurney, Kurz and Fredericks. It was not long before British photographers realised the possibilities of the new medium, and glamour photography began to be practised in London by Barraud, Bassano, Downey, Elliot and Fry, and the London Stereoscopic Company. Howell took the charmingly sentimental portrait of Grace Rawlinson on the right.

and marble columns. He had over a hundred and fifty different back-drops. Some of his more acclaimed photographs were of snow scenes produced in his studio for *The Two Orphans*. He was also invited to photograph social events, including *bals masqués*. In time his became the largest photographer's business in New York, partly because of the huge stock of portraits of the stars which he accumulated and which he sold for the actresses on a royalty basis. He was reputed to hold in stock over three hundred poses of Maud Branscombe, and to have sold over thirty thousand prints of them. On the right is his cabinet photograph of Rosa Rand, whose flamboyant hat throws into charming contrast her petite features.

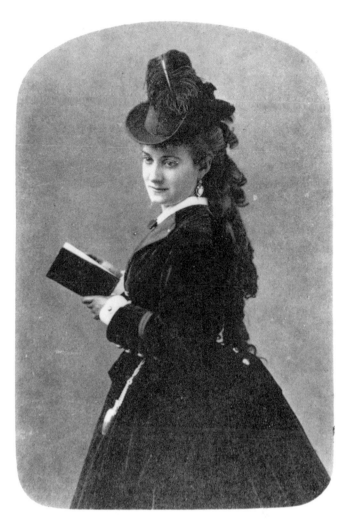

75

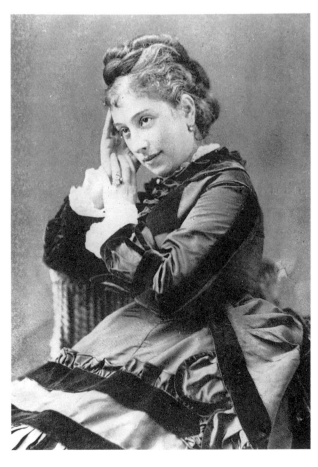

HOWELL

It was disingenuous of Howell to portray the lady on the left in so demure and pensive a pose, for the sitter was a notorious courtesan, one of the *grandes cocottes* of Paris during the Second Empire. She was Cora Pearl, whose name is a recurrent chime in the amorous reminiscences of the period in which the painter Puvis de Chavannes declared 'There is nothing better in the world than passionately loving women and voluptuousness'.

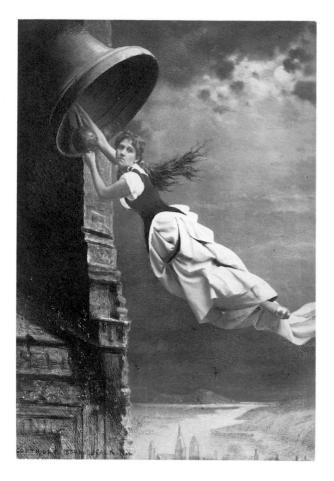

Benjamin Joseph Falk was one of the last New York photographers to turn to the cabinet photograph. Between 1884 and 1891 he specialised in theatrical subjects and accumulated thousands of stock prints. In 1891 he moved into Broadway and in the following year he invented an automatic printing machine, which was the first to make use of mass-production techniques. Although he made a large income from glamour photographs of the stars he also branched out into allegorical photography.

On these pages are examples of Falk's fascination with trick photography as an illustration of literary or historical themes. Above, on this page, is his ingenious but slightly improbable interpretation of lines from a poem called *The Curfew:* 'Out she swung, far out. The city seemed a speck of light below'. In this shot the aeronautical bellringer was a Mrs Charles Watson. On the right is the actress Ida Muller giving an airborne impression of Cupid aiming his arrow at a ruined castle in a somewhat desolate landscape. One wonders what poetic image Falk had in mind in this case.

Falk was adept at making use of photographic tricks and illusions, showing ladies flying through space, swinging from bell ropes in church steeples, or cast up on the Rock of Ages. Such gimmicks had an enormous appeal for the Victorian viewer, combining sentimental themes or situations with the kind of improbabilities we now associate with science fiction. On the right is the delightfully named Preciosa Grigolatis as 'The Flying Fairy', rising, without the apparent aid of any balloon or wires, above what one takes to be the Brooklyn Bridge, which had just been completed in 1883.

77

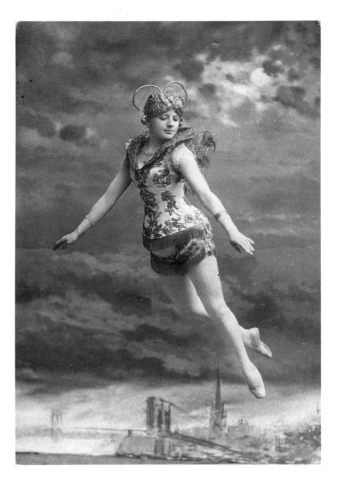

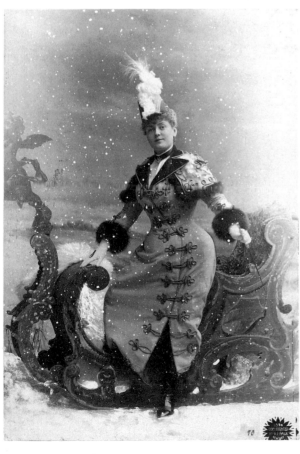

Down to earth this time. The elegant Lillian Russell is photographed by Falk in 1890 descending from her Russian sleigh in Czarina's costume and a snowstorm. Note that the snowflakes are not painted on the backcloth: they are visibly falling from the studio ceiling onto the sleigh and the regally imperturbable Lillian Russell. From every point of view this had to be a rapid exposure.

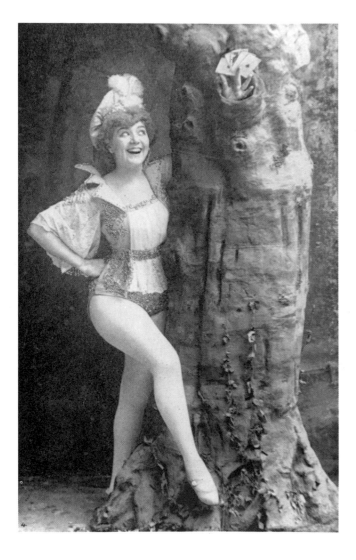

FALK

The photograph on the left can be dated from 1891, when Falk had moved his studio from West Twenty-fourth Street to 949 Broadway. Philip Kaplan, after commenting on the ingenuity of Falk's allegorical subjects, says that 'in general, his touch was light and whimsical, and the public loved his gay approach to the 'nineties'. Here the word 'gay' is not to be taken in its debased modern context, but in the true 'nineties sense of 'gallant' – or even 'saucy'. It would, indeed, be difficult to surpass for sauciness the pose adopted by Jennie Joyce. The exposure of the elegant thigh, the jaunty hand on hip, and the knowing smile, are all object lessons in feminine allure. And Joseph Falk has rounded them off with one of his characteristic exercises in ingenuity – the hand of playing cards emerging from a hole in the hollow (*papier-maché*)

78

Surprisingly, the famous photograph of a famous actress, on the right, is not the product of a famous studio. It is a mass produced print reproduced in thousands by a process called Woodburytype. The subject is Sarah Bernhardt, and apart from the photographer's skill in composition and arrangement of props it is of unusual interest in showing the outstanding serious actress of her day wearing trousers.

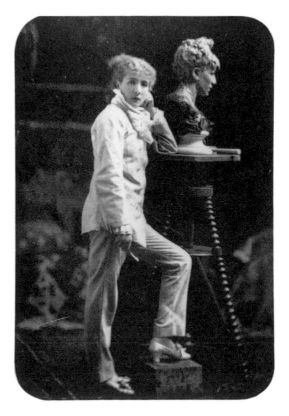

tree trunk. A gem worthy of a place of honour in Mr Ronnie Barker's collection of saucy postcards.

Benjamin Joseph Falk was not only an ingenious photographer but one with a journalist's sense of topicality. His portrait of Belle Archer, on the right, photographed after he had moved his studio to Broadway in 1891, is a brilliant evocation of the 'New Woman' who had been discovered by a well-known journalist, Mrs Lynn Lynton, and described in 1868 in the London *Saturday Review*. Mrs Lynton emphasised the word 'fast', which, she wrote, 'is an Americanism and extremely vulgar. A fast young woman has an inordinate love of gaiety, a bold determined manner, a total absence of respect towards her elders; a flippant style of conversation and a glaring and sometimes immodest dress. In the country she is a daring rider: in town she plays billiards'. And, as Mr Falk revealed, she smoked cigarettes.

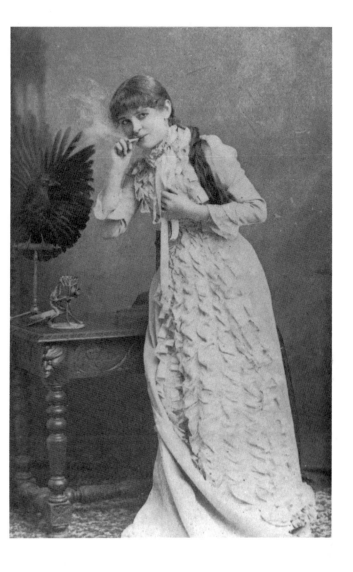

79

This revealing portrait of Marie Bashkirtseff (on the left) taken by an unknown photographer in 1885, shows that not only actresses and popular entertainers attracted the eye and purse of the glamour photographers. Marie Bashkirtseff was the daughter of wealthy Russian parents, and was endowed not only with beautiful features but also a beautiful voice. Although she is mainly remembered today for her private diary, kept from the age of thirteen to her death from consumption when only twenty-four, she was also a talented painter.

UST AS THE LATTER HALF of the eighteenth century marked the beginning of the Industrial Revolution in Britain, and the twentieth century inaugurated the technological revolutions of our own time, so the Victorian era was notable for another sort of scientific revolution – in the field of natural history. Indeed Lynn Barber, who wrote an admirable survey of this Victorian phenomenon, entitled her book *The Heyday of Natural History*.

The giants in this sphere, obviously, were Thomas Henry Huxley and Charles Darwin, but almost every branch of natural history had its specialist; and enthusiasm for every aspect of natural history, from geology to mycology, ran through the middle strata of English society. Kew Gardens, which had been set up as a place of royal recreation by the mother of George III, was handed over to the nation by Queen Victoria in 1840. The Zoological Gardens were established in Regent's Park, London, in 1828, and the South Kensington Museum – a favourite resort of Beatrix Potter, whose family lived nearby – was opened in 1851 by Queen Victoria and the Prince Consort.

In the eighteen-thirties the Wardian Case was invented by a surgeon named Nathaniel Bagshaw Ward, to enable chrysalises and seeds to thrive in airtight compartments. Soon no drawing-room was properly furnished without its Wardian Case, or its rival attraction, the aquarium for marine plants.

A 'fern craze' swept the country, and 'botanising' became a favourite recreation of gentlewomen. Before long the artistic possibilities of botany were recognised by countless young ladies who had been taught to draw and paint in watercolours. In mid-century one of them, Anne Pratt, had such outstanding talent and industry that her books became best-sellers.

Born in 1806, one of the three daughters of a wholesaler grocer in Kent, Anne Pratt compensated for 'delicate health' by studying botany, and, helped by her sister who collected plants for her, she formed an extensive herbarium. In the course of time she began to make drawings of her specimens. After publishing several miscellaneous books on wild flowers and birds, with a little religion thrown in, she published in 1855 *The Flowering Plants and Ferns of Great Britain*, in five volumes illustrated with numerous watercolour drawings. In 1866 she married John Peerless, of East Grinstead, and later she lived for some years at Redhill in Surrey. She published several more books, on ferns, poisonous plants, and grasses and sedges, all illustrated by herself.

I understand that Anne Pratt is not now rated highly as a botanist, and perhaps that is why there is only a passing reference to her in the book by Lynn Barber which I have quoted, and no mention whatever in two of the chief modern encyclopaedias. But she was a most accomplished draughts-woman, with an excellent sense of colour and composition, and I imagine she was largely responsible for encouraging many women to take up flower painting in the later years of the century. She died in London in 1893. She does not deserve neglect.

Edward Lear became famous, as everyone knows, for his *Book of Nonsense*, and in our own time has achieved a different fame as one of the most individual landscape artists of the Victorian Age. Not everyone remembers that his nonsense rhymes were written merely to amuse the children and grandchildren of the Earl of Derby whilst Lear was staying at Knowsley, near Liverpool, in order to make drawings of the animals in the large private menagerie built up by Lord Derby's heir, Lord Stanley.

Lear, in fact, started his working life as a scientific naturalist, who had a talent for drawing, and it was only an affliction of asthma and bronchitis that

80

Ten Vetches from *The Flowering Plants and Ferns of Great Britain* by Anne Pratt, 1855. The plants illustrated are the Yellow Vetchling, the Crimson Vetch, the Rough Podded Vetch, the Meadow Vetch, the Narrow-leaved Everlasting Pea, the Broad leaved Everlasting Pea, the Black Bitter Vetch, the Blue Marsh Vetch, the Seaside Everlasting Vetch, the Tuberous Bitter Vetch. *Private Collection*

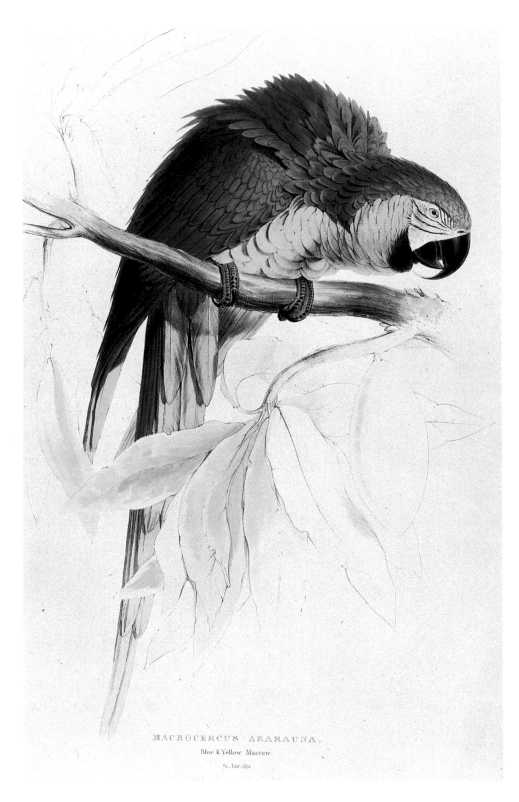

The Blue and Yellow Macaw, by Edward Lear. One of the *Illustrations of the Family of Psittacidae, or Parrots*, published between 1830 and 1832. Coming from the library of the Duke of Northumberland, this copy of the book was sold by Sotheby's in 1986 for £48,400.

MACROCERCUS ARARAUNA.
Blue & Yellow Maccaw.
¾ Nat Size

made him leave Knowsley and seek better health in Italy, where he deserted zoology and turned to landscape painting. Before he had gone to Knowsley, however, he had completed, between June 1830 and April 1831 a series of drawings, which he himself issued to subscribers in twelve folios, entitled *Illustrations of the Family of Psittacidae, or Parrots*. Although only 175 copies were printed, and the plates were destroyed after printing, the venture brought high praise from Lord Stanley, then President of the Zoological Society.

82

The Kite: one of the
illustrations after Joseph
Wolf in John Gould's
Birds of Great Britain,
1873. *The British Library*

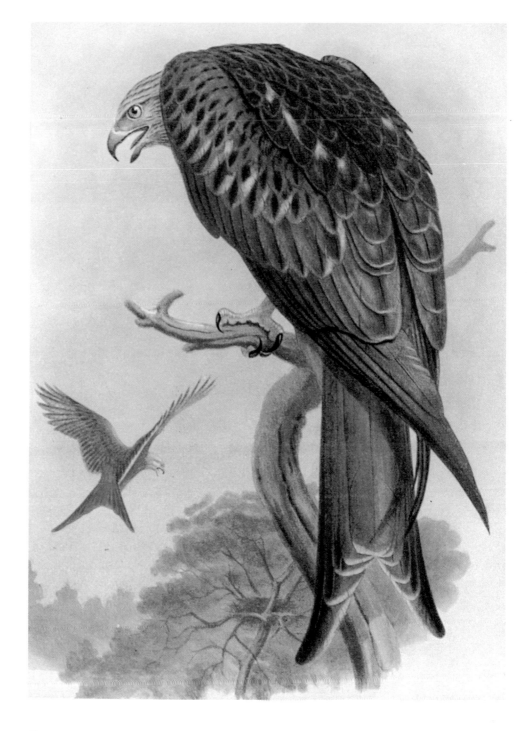

Lear's *Parrots* was an astonishing feat for a young man to accomplish before
reaching the age of twenty. As so few copies were printed, few people have
ever seen the original plates. Lear collaborated, without acknowledgement, in
Gould's *Century of Birds from the Himalayan Mountains*, published in 1831.
Later he collaborated in a book on *Tortoises, Terrapins and Turtles*.

Mention of John Gould brings me to the man who is usually regarded,
after Audubon, as the outstanding bird artist of the period. Gould's father
was foreman of gardeners at Windsor Castle, and in 1827 John became
taxidermist of the Zoological Society of London. One surmises that most of
Gould's drawings were based on study of skins of exotic birds, and there is no
doubt that they were transferred to the lithographic stone by his wife, who

worked on all Gould's books until her death in 1841. During this period they produced the five-volume *Birds of Europe*, 1832–37, and a monograph on toucans in 1834. The success of these enabled the Goulds to spend two years in Australia, which led to the publication of Gould's famous work *The Birds of Australia*, in seven volumes, 1840–48, which is one of the most outstanding illustrated works of the century. Between 1849 and 1861 he produced his splendid monograph on *Humming Birds*.

Although there is no doubt of Gould's vast ornithological knowledge, for which he was elected a Fellow of the Royal Society in 1843, his impressive series of some forty volumes, containing over three thousand coloured plates, obviously owed a large part of their artistic appeal to the work of his wife, of Lear, who worked for him for some six years, and other artists such as Joseph Wolf, whose contribution to *The Birds of Great Britain* (1873) was acknowledged.

Gould was, as I have said earlier, an impresario, and he left a vast monument to his industry and flair, but as an artist he can hardly stand comparison with his American contemporary, John James Audubon.

He had, however, an English contemporary, working in a very different sphere, who seems to me to have been a brilliantly original artist, though he is hardly known today for his own genius, but merely for having been the father of the literary critic, Sir Edmund Gosse. The son wrote an enthralling study of his own childhood and the life of his extraordinary father, who was not only a dedicated scientist and artist, but almost a religious megalomaniac.

Philip Henry Gosse was born in 1810 in Poole, Dorset, the son of a miniature painter who only just struggled for a livelihood. Philip was sent at the age of seventeen to Newfoundland, where he worked as a shipping clerk. He became interested in entomology and also became a deeply committed Christian. On his return to England he took a post as a schoolmaster, and was commissioned by the Society for Promoting Christian Knowledge (who also published the early work of Anne Pratt) to write an *Introduction to Zoology*. This was followed by a book on *The Ocean* in 1845, which had a considerable success in Britain and America. After a visit to Jamaica, which generated three books, he returned to England again and specialised in marine zoology.

His book *A Naturalist's Rambles on the Devonshire Coast* (1853) was followed by *The Aquarium* (1854), which not only had a huge sale, but initiated the craze for aquaria in middle-class homes. Gosse supervised every detail of the

On the right: Actinia
Mesembryanthemum.
Left, centre: *Actina
chiococca*. Right, centre:
Sacartia chrysosplenum.
Left, at foot: *Anthea
cereus*, above *Tealia
digitata*. Right, at foot:
Sagartia viduata.
Watercolour drawing by
Philip Henry Gosse.
Lithographed in colour
by W. Dickes.
*A History of the British
Sea Anemonies and
Corals*, by Philip H.
Gosse, 1860.
London Library

printing of this book, and learned to make his own drawings directly on the lithographic stone. It was a triumph of chromo-lithography, the plates giving every appearance of being hand-coloured.

He continued his researches into marine zoology and in 1856 was elected a Fellow of the Royal Society. Between 1858 and 1860 he published a masterly work on sea anemones and corals, the *Actinologia Britannica*. Throughout this period his passionate religious beliefs were vehemently expressed on every occasion, frequently in his books. Today this often arouses derision. But to appreciate the real genius and dedication of the naturalist, one has only to look at his marvellous illustrations of underwater creatures, plants, shells and corals, and read his son's vivid account of accompanying his father on his forays. What follows is from *Father and Son*, published in 1907.

'It was down on the shore' Edmund Gosse wrote, 'tramping along the pebbled terraces of the beach, clambering over the great blocks of fallen conglomerate which broke the white curve with rufous promontories that

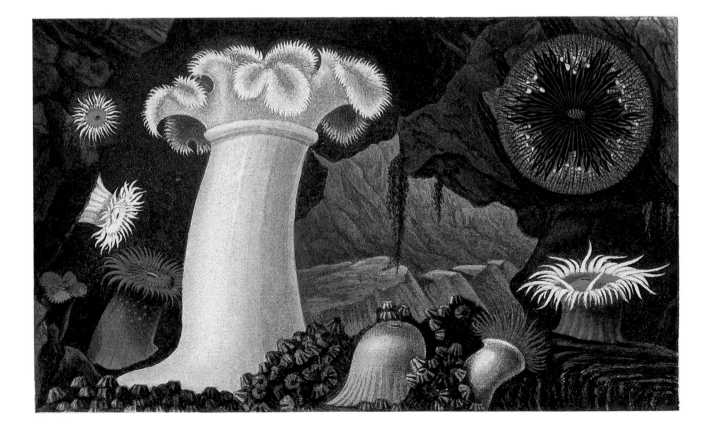

87

jutted into the sea, or, finally, bending over those shallow tidal pools in the limestone rocks which were our proper hunting-ground – it was in such circumstances as these that my Father became most easy, most happy, most human. That hard look across his brows, which it wearied me to see, the look that came from sleepless anxiety of conscience, faded away, and left the dark countenance still always stern indeed, but serene and unupbraiding. Those pools were our mirrors, in which, reflected in the dark hyaline and framed by the sleek and shining fronds of oar-weed there used to appear the shapes of a middle-aged man and a funny little boy, equally well prepared for business.

'If any one goes down to those shores now, if man or boy seek to follow in our traces, let him realise at once, before he takes the trouble to roll up his sleeves, that his zeal will end in labour lost. There is nothing, now, where in our days there was so much. Then the rocks between the tide and tide were submarine gardens of a beauty that seemed often to be fabulous, and was positively delusive, since, if we delicately lifted the weed-curtains of a windless pool, though we might for a moment see its sides and floor paven with living blossoms, ivory-white, rosy-red, orange and amethyst, yet all that panoply would melt away, furled into the hollow rock, if we so much as dropped a pebble in to disturb the magic dream.

'Half a century ago, in many parts of the coast of Devonshire and Cornwall, where the limestone at the water's edge is wrought into crevices and hollows, the tide-line was, like Keats' Grecian vase "a still unravished bride of quietness". These cups and basins were always full, whether the tide was high or low, and the only way in which they were affected was that twice in the twenty-four hours they were replenished by cold streams from the great sea, and then twice were left brimming to be vivified by the temperate movement of the upper air. They were living flower-beds, so exquisite in their perfection, that my Father, in spite of his scientific requirements, used not seldom to pause before he began to rifle them, ejaculating that it was indeed a pity to disturb such congregated beauty. The antiquity of these rock-pools, and the infinite succession of the soft and radiant forms, sea-anemones, seaweeds, shells, fishes, which had inhabited them, undisturbed since the creation of the world, used to occupy my Father's fancy. We burst in, he used to say, where no one had ever thought of intruding before; and, if the Garden of Eden had been situate in Devonshire, Adam and Eve, stepping lightly down to bathe in the rainbow-coloured spray, would have seen the identical sights that we now saw – the great prawns gliding like transparent launches, anthea waving in the twilight its thick white waxen tentacles, and the fronds of the dulse faintly streaming on the water, like huge red banners in some reverted atmosphere.'

One must assume that this dedicated scientist, so single-minded in his pursuit of zoological classifications and variations, had picked up a certain amount of expertise in the use of pencil and brush from his own father, the miniature painter. But there is no evidence that Philip Gosse ever attended an art school or was professionally initiated into the technique of painting. That he learnt to portray the fantastic and otherwise unrecorded beauties of underwater life is one of the unexplained mysteries of artistic creation.

Another extraordinary fact for which we and Gosse's followers must be grateful is that he found engravers and printers whose technical skill was such that a modern authority on book production, Mr Ruari McLean, wrote in his book on *Victorian Book Design and Illustration* (1972) that 'the softness, subtlety and richness of the colouring far exceeds in quality the best achieved by the four-colour processes of today.'

88

VALENTINE CARDS

HERE USED TO BE A LEGEND that the reason for celebrating St Valentine's Day with declarations of love was that on the eve of his execution by the Roman Emperor Claudius II the early Christian martyr Valentinus sent a letter of affection to his jailer's daughter, who had befriended him.

I am sorry to say I have found no historical basis for this charming legend. Nor have I happened to be in Rome on February the fourteenth, and I have therefore been unable to substantiate the further legend that on that day a pink almond tree breaks out into blossom near the church of Praxedes where St Valentine is reputed to be buried.

What is incontestible, however, is that the fourteenth of February coincides with the pagan festival of Lupercalia, when Romans commemorated the ancient rural god Faunus, patron of husbandry and guardian of the secrets of nature. During the Lupercalia the birds of the air were believed to choose their mates for the coming season; and indeed it is very probable that many of them did. At this time the Romans also celebrated the feast of Juno Regina, at which boys drew by the lot the names of girls who were to partner them in the celebration.

The early Christians, as is well known, did not hesitate to turn to their advantage many existing pagan customs; and what is more likely than that they appropriated pagan rites of spring which had a logical seasonal origin, and sanctified them with the name of the Saint who happened to have been martyred in the midst of the Lupercalian festivities?

In seventeenth-century England the poet Robert Herrick wrote a poem 'To his Valentine, on St Valentine's Day', which begins with the lines:

Oft have I heard both youths and virgins say
Birds choose their mates, and couple too, this day.

Michael Drayton in one of his poems refers to Valentines, or what we today might call 'boy-friends' or 'girl-friends', being chosen by lot. Samuel Pepys never failed to celebrate St Valentine's day, and it is clear from entries in his diary that married men were fully entitled to join in the fun. Pepys took no exception to his wife making her own choice of a Valentine, particulary if the gentleman in question were Sir William Batten, Surveyor of the Navy, who announced his passion with 'half-a-dozen pair of gloves and a pair of silk stockings and garters'. One should perhaps mention that Pepys himself had already chosen Sir William Batten's daughter for *his* Valentine, which he regretted a year later, 'there being no great friendship between us now'.

In Pepys's diary we can also trace the superseding of such gifts as gloves and garters, and their replacement by written missives. On February 14, 1667, 'little Will Mercer' had become Mrs Pepys's Valentine, and he 'brought her name writ upon blue paper in gold letters, done by himself, very pretty'. Here, quite clearly, is an early example of the kind of valentine card we know today. (In case anyone questions the propriety of these exchanges it should be borne in mind that 'little Will Mercer' was the sixteen-year old brother of Mrs Pepys's maidservant, Mary Mercer.)

Pepys, being the prudent man he was, was often exercised by the cost of Valentine gifts and he never rose to the heights of the Duke of York, who, becoming the Valentine of the lovely Lady Arabella Stuart, 'did give her a jewel of about £800', though he believed her to be 'as virtuous as any woman in the world'. In her case virtue regularly got its reward, for Pepys recorded that Lord Mandeville became her Valentine in another year, and gave her another ring, though this one was only worth £300.

89

The elegantly composed quarto card opposite is surrounded by an embossed and perforated lace-paper design identical with one by Dobbs, Bailey & Co. produced c.1850. Roses are frequent elements in the symbolism of valentines, but the combination of a rose bloom with an infant cupid is unusual. 260 × 220mm. The slightly illegible note pinned to the card reads:

Oh, I should like to
marry
If I could only find
Any loving partner
Suited to my mind

One wonders whether the writer of the note observed the number of thorns on the stem of the rose!
Museum of London

I with rapture view this pair,
Hymens joys I wish to share,
Let Cupid guide you to the spot,
To make me blest in mortal lot,
My earthly Angel, you shall be,
I'll love, but love no one but the.

90

Gifts on this scale were given only by the aristocracy. *Poor Robin's Almanack*, in its entry for February 1684, forecast that 'on the fourteenth day the Milleners will have great sale for gloves and ribbons'.

In the eighteenth century the idea of a lottery seems to have been revived. Unmarried people wrote their names, or feigned names, on pieces of paper, which were drawn by men and women in turn, and Valentines were chosen or nominated by the luck of the draw. Few of these genuine or feigned love-letters were dispatched, for there was no penny-post except in London, and the cost of sending a letter in country districts depended on the distance involved and the number of sheets. A visiting card, or the blank side of a playing card, was often used as a substitute valentine card.

The more elaborate valentine card, embellished with drawings of birds or flowers or hearts, surrounded by written messages, seems to have been more common in America than in England, though this may only seem to be so because so many of the early decorative cards found their way during later years into the more adventurous American museums.

The John Johnson Collection, now in the Bodleian Library, Oxford, has a copy of a book called *The Complete British Valentine Writer, or The High*

The recipient of the elegant card opposite, clearly a maiden lady as she wears no hat out-of-doors, was also of a comfortable station in life, living in a spacious landscaped garden. Her costume belongs to the pre-crinoline era, the crinoline not having been patented until 1856. The garden sculpture has a solid early-Victorian look, but the delicacy is almost Pre-Victorian.
255 × 205mm.
Museum of London

Those lines retrace, thy beauteous face,
Thy form,—thy noble bearing;
Tho absent thou,—thy image now,
Is still my heart ensnaring.

How can I want the love to grant,
And thou so kindly pressing;
I am thine own, my dearest one
Scorn not this heart confessing.

Road to Love for Both Sexes, published in London in 1794. From this date onwards, and through the Regency period, the valentine card was quickly established as a popular art form.

Valentine cards were so popular that their production became a flourishing trade amongst cheapjack printers in central London. In view of their sentimental associations valentines tended to be preserved and cherished more than other forms of ephemeral printed matter. And the ingenuity and invention

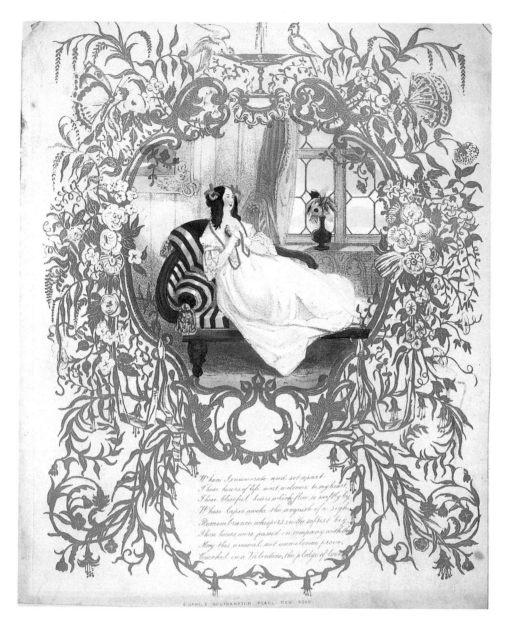

On the left: a card with a decorative border printed in gold, the central design being hand-coloured by stencil. Published by E. Dawe, 9 Southampton Place, New Road. c.1840 255 × 200mm.
Museum of London

devoted to their design, in a highly competitive market, meant that every sort of artistic cliché and printer's sense of whimsy was called upon. Even if one eliminates the crude vulgarities that rose little above the level of the humorous verses in Christmas cards, it is difficult to find any consistent or distinctive artistic motifs running through the vast picture gallery of Victorian valentines.

Painstaking analysis of the various themes have been attempted by social historians, most notably by Frank Staff, in his meticulous study of *The Valentine and its Origins* (Lutterworth Press, 1969). Even he, however, found if difficult to trace any true aesthetic impulse that was characteristic of the Victorian period, once the elegance of Regency designers had been superseded by the exuberance of the typical mid-Victorian card. There was no end to the ingenuity devoted to the different designs of lace paper, embossed envelopes, glass or metal mirrors, ribbons, dried ferns, and fake advertisements, bank notes and marriage licences.

A church is not an uncommon element in valentines. One of the messages appended to this charming combination of religious, floral and ornithological symbolism is 'Wanted, a Mate. The Applicant can give positive proof that strict honor is his plan'.
240 × 200mm.
Museum of London

The Hallmark Historical Collection, the Norcross Collection and the Collection formed by Carroll Alton Means in the United States all possess fantastic constructions of paper, lace, and printing gimmicks.

In making an inevitably restricted choice of illustrations for this book I have drawn solely on that part of the collection formed by the most famous producer of valentines in the nineteenth century, Jonathan King, which is now stored in the Museum of London (an even larger part of it is in the Hallmark Collection in Kansas City). Jonathan King was a stationer and newsagent who opened a shop near Kings Cross in London in 1845, and was a pioneer in the production of lace-paper valentines, mostly fabricated by his wife, who discovered the decorative possibilities of tinsel, birds' feathers and powdered coloured glass. Jonathan King prospered and moved to Euston Square, and when he died in 1869 passed on his business to his son and daughter-in-law.

Not content with making a huge success of his business, Jonathan King junior assembled the largest known collection of valentines, not only his own and his father's, but examples of every kind. In the course of time some forty

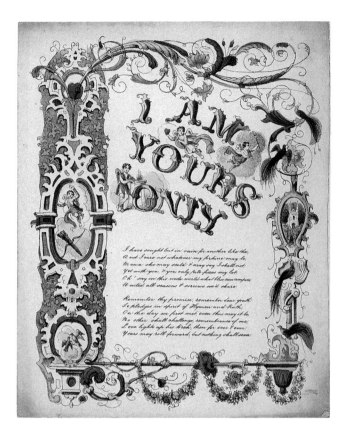

On the left is a card published by A. Park of 47 Leonard Street, Finsbury, London, which is an example of mid-Victorian design in its most ebullient form. It dates from 1850 and is hand-coloured. 255 × 200mm. Arthur Park also printed woodcuts for toy theatres.
Museum of London

94

On the right: probably from the same designer as the card above. It is printed in black and coloured by hand. c1850
250 × 200mm.
Museum of London

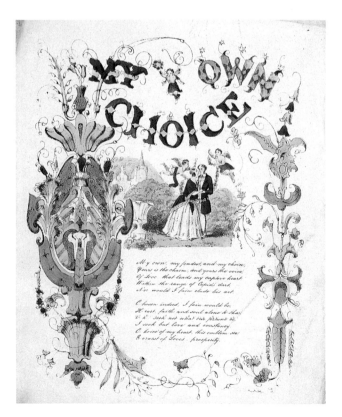

On the right is one of a
series of alphabetical
cards denoting
'Sentimental Trades'.
They date from 1850 to
1860. But what trade is
this man engaged in?
230 × 185mm.
Museum of London

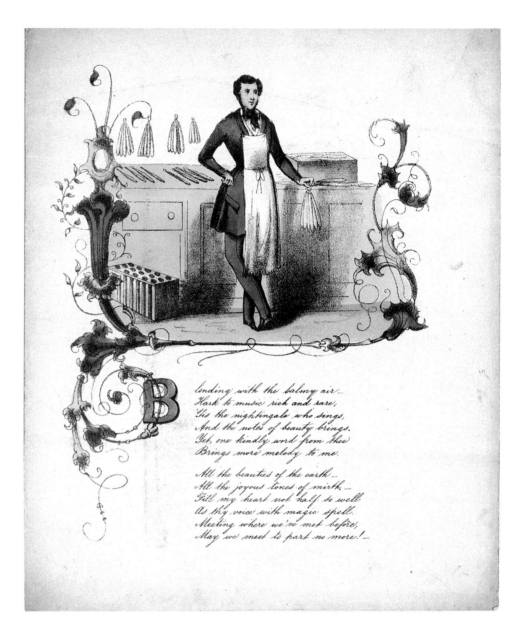

lending with the balmy air—
Hark to music rich and rare;
'Tis the nightingale who sings,
And the notes of beauty brings.
Yet, one kindly word from thee
Brings more melody to me.

All the beauties of the earth—
All the joyous tones of mirth—
Fill my heart not half so well
As thy voice with magic spell.
Meeting where we've met before,
May we meet to part no more!—

large folio volumes, containing about a hundred tinsel pictures and nine
thousand sheets of prints, found their way to the Museum of London.

This invaluable collection cries out for some dedicated student of printed
ephemera to devote his or her energy and scholarship to sorting, analysing
and classifying what is clearly a massive monument of social history. Whether
its aesthetic interest quite matches up to its value as entertaining Victoriana I
am not so sure. For all the ingenuity, inventiveness and profusion of decorative
skills which Jonathan King and his contemporaries devoted to the valentine, I
doubt if many of the cards, apart from some of those produced in the
Regency period, qualify for that place in the history of taste which is claimed
by, say, the Victorian fashion plate, the early Staffordshire pottery figures,
the music covers of Concanen and his contemporaries, and even the modest
woodcuts of the Victorian toy theatre.

An unusual combination of several elements of the vintage valentine card: the classical gilt frame, the bizarre decoration that surrounds it, a verse, and a posy of flowers that (perhaps wisely) obliterates most of the verse. 170 × 110mm. *Museum of London*

When?

When will the golden sun
once again shine?
When will the cold moon
throw shadows no more?
Only when I in silence
adored
Through by
The

MAYHEM
AND
MURDER

 S A CONTRAST TO the saccharine sentiments which the Victorians indulged in with unselfconscious abandon one may perhaps be historically justified in sparing a glance for the other side of the picture. It was not merely Cupid's arrow that took its toll of the female population. Other forms of attack were a lively element in the Victorian scene.

It is a truism that the media of today – press, television, films and radio – are obsessed with crime and violence, thereby corrupting the innocent minds of the young, and by bad example encouraging the misdeeds which they record so eagerly. 'It wasn't like that in the old days' we are assured complacently by our elders.

Wasn't it? In recording the seamy side of life the Victorian media did so with a panache and graphic gusto which is not only shocking to modern eyes, but pulls no visual punches on the aesthetic responses of the modern viewer.

The examples which follow, taken mostly from a sober and high-minded organ of the Victorian establishment, *The Illustrated Police News* (by courtesy of the BBC Hulton Picture Library) are not only interesting as illustrating the voyeuristic appetites of a public noted for its preoccupation with morality and respect for the Law, but in so doing they created an art form which bears comparison with the drawings of Cruikshank and Phiz.

97

Joseph Myers murdering his wife at Sheffield in June 1864.
Illustrated Police News
18 June 1864

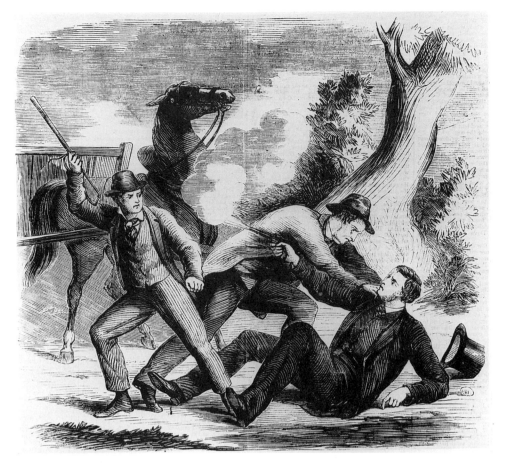

Attempted murder and
highway robbery near
Dublin. Thomas O'Flynn
attacking Farmer
Cumming and his son.
Illustrated Police News
9 September 1865

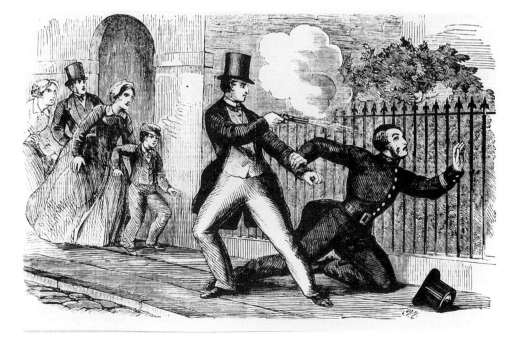

Walter Jones murdering
Police-Sargeant Drew at
Worcester.
Illustrated Police News
23 April 1864

George Hall shoots his
wife in Dartmouth Street,
Birmingham.
Illustrated Police News
27 February 1864

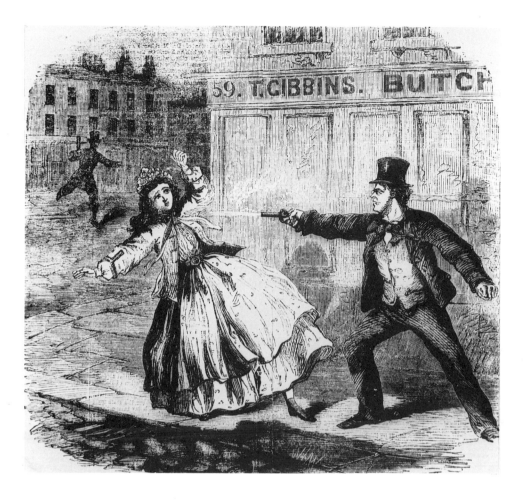

Murder of Mrs Hunt at
Cambridge. She was
unable to identify her
assailant before she died
(not surprisingly).
Illustrated Police News
26 March 1864

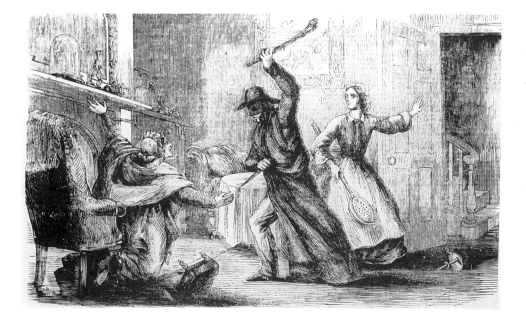

Attempted murder in
Hackney Road. Escape
of Mrs Moratti from the
window (sketched on the
spot). Moratti attempted
to murder his wife, and
then cut his own throat.
Both recovered.
Illustrated Police News
20 May 1865

Attempted murder and
suicide at Bank Top,
Macclesfield, James
Cotterill, silk weaver, cut
his son's throat and then
his own.
Illustrated Police News
13 August 1864

Joseph Morris shooting
his wife whilst she was
doing the washing-up.
Illustrated Police News
22 October 1864

Police finding the head of
Theodore Christian
Fuhrop on Plaistow
Marshes. He had been
murdered by Karl Kohl.
Illustrated Police News
26 November 1864

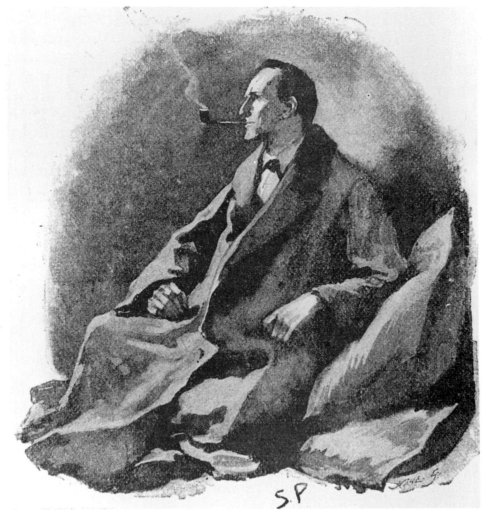

 DOUBT IF THERE IS ANY CHARACTER in English fiction or drama whose attributes and activities are as generally familiar to the world at large as those of Sherlock Holmes. If he were to walk today into anyone's living room he would be recognisable by nine out of ten adult readers, more readily even than such outsize characters as Falstaff or Mr Pickwick.

There are several reasons for this – the vogue for detective stories in which he was the prime figure, and the number of plays, films and television programmes in which he has been impersonated. But I suggest that the initial reason for the recognizability of Sherlock Holmes is the artist who created his visual image, Sidney Paget. Here is a minor illustrator who happened to create the most famous features in the world's fiction. Not even James Bond can compete, despite the vast sales of the James Bond books and their spectacular success as films. For their central character has appeared in the image of three quite different actors. The same argument applies to the only other detective of a fame sufficient to challenge that of Sherlock Holmes, Hercule Poirot.

Sherlock Holmes, of course, has been played on stage and film and television by more than one actor, of whom perhaps the best known was Basil Rathbone, or more recently, Douglas Wilmer. But all have been at pains to model their performances on the aquiline features immortalised by Sidney Paget. The same applies to those actors who have attempted to portray Dr Watson, of whom perhaps the nearest to 'life' was perhaps the late Nigel Bruce.

102

Above: from 'The Adventure of the Man with the Twisted Lip'. *The Strand Magazine* December 1891

Baker Street Irregulars may venerate Sidney Paget, but to the world at large he is just the initials S.P. appended to the drawings which appeared in *The Strand Magazine*. He occupies minimal space in dictionaries of Victorian painting, which merely tell us that he lived from 1860 to 1908, exhibited some portraits and *genre* paintings at the Royal Academy between 1879 and 1903, illustrated Scott as well as Conan Doyle, and had two brothers who were also illustrators.

The following pages are a brief tribute to an artist who created the visual image of one of the Victorian immortals. The illustrations have been photographed from the original reproductions in *The Strand Magazine* which became famous for the series of Sherlock Holmes stories published between the years 1891 and 1893.

The reproductions in *The Strand Magazine* vary considerably in quality. Photographic enlargements of several of them, even such late examples as those for 'The Final Problem', indicate that they were mostly reproduced from engravings on wood, whereas, others, such as the vignettes reproduced here on these two pages, appear to have been treated with a printer's mechanical screen. Those which have the clearest engraved lines usually bear both Paget's initials and, less conspicuously, the initials 'PNSc.' which denote the identity of the craft engraver.

Although the illustrations reproduced here are chosen primarily to illustrate Paget's visual treatment of Holmes's features and characteristic expressions in varying situations, it is interesting to see how the accompanying brief quotations from the text, chosen simply for their relevance to the illustrations, provide in themselves a miniature anthology of characteristic Holmes *dicta* and examples of his 'methods'.

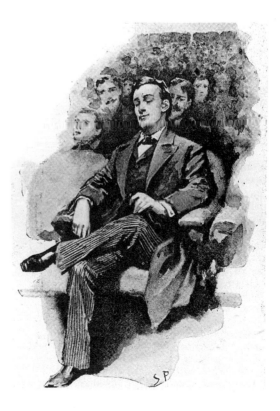

From 'The Adventure of
the Red-headed League'
The Strand Magazine
August 1891

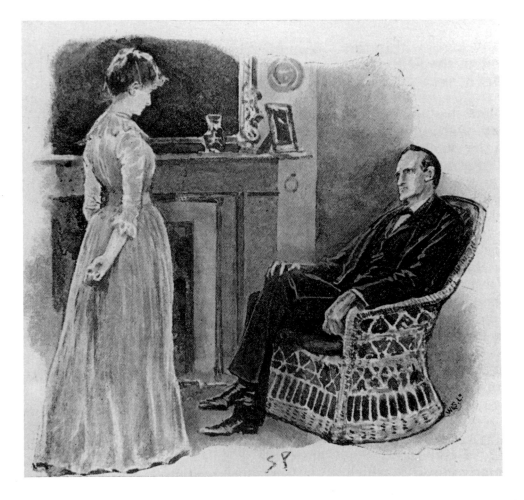

From 'The Adventure of
the Man with the Twisted
Lip'. *The Strand Magazine*
December 1891

 HAD LEFT MY CHAIR, and was gazing over his shoulder. The envelope was a very coarse one, and was stamped with the Gravesend post-mark, and with the date of that very day, or rather of the day before, for it was considerably after midnight.

'Coarse writing!' murmured Holmes. 'Surely this is not your husband's writing, madam?'

'No, but the enclosure is.'

'I perceive also that whoever addressed the envelope had to go and inquire as to the address.'

'How can you tell that?'

'The name, you see, is in perfectly black ink, which has dried itself. The rest is of the greyish colour which shows that blotting-paper has been used. If it had been written straight off, and then blotted, none would be of a deep black shade. This man has written the name, and there has been a pause before he wrote the address, which can only mean that he was not familiar with it . . .'

'And you are sure that this is your husband's hand?'

'His hand when he wrote hurriedly. It is very unlike his usual writing.'

'"*Dearest, do not be frightened. All will come well. There is a huge error which it may take some little time to rectify. Wait in patience. – Neville.*" Written in pencil upon the fly-leaf of a book, octavo size, no watermark. Hum! Posted today in Gravesend by a man with a dirty thumb. Ha! and the flap has been gummed, if I am not very much in error, by a person who had been chewing tobacco.'

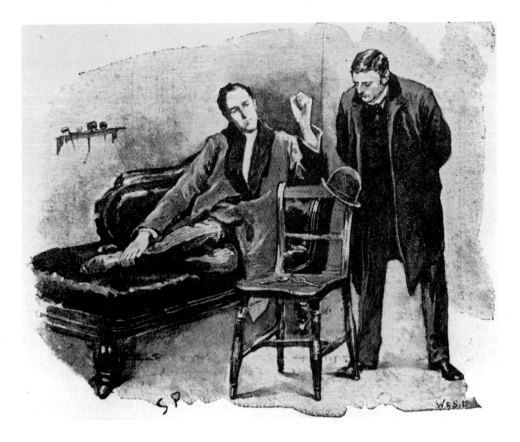

ERE IS MY LENS. You know my methods. What can you gather yourself as to the individuality of the man who has worn this article . . .?'

He picked it up, and gazed at it in the peculiar introspective fashion which was characteristic of him. 'It is perhaps less suggestive than it might have been,' he remarked, 'and yet there are a few inferences which are very distinct, and a few others which represent at least a strong balance of probability. That the man was highly intellectual is of course obvious upon the face of it, and also that he was fairly well-to-do within the last three years, although he has now fallen upon evil days. He had foresight, but has less now than formerly, pointing to a moral retrogression, which, when taken with the decline of his fortunes, seems to indicate some evil influence, probably drink, at work upon him. This may account also for the obvious fact that his wife has ceased to love him.'

'My dear Holmes!'

'He has, however, retained some degree of self-respect,' he continued, disregarding my remonstrance. 'He is a man who leads a sedentary life, goes out little, is out of training entirely, is middle-aged, has grizzled hair which he has had cut within the last few days, and which he anoints with lime-cream. These are the more patent facts which are to be deduced from his hat. Also, by the way, that it is extremely improbable that he has gas laid on in his house.'

'But his wife – you said that she had ceased to love him.'

'This hat has not been brushed for weeks. When I see you, my dear Watson, with a week's accumulation of dust upon your hat, and when your wife allows you to go out in such a state, I shall fear that you also have been unfortunate enough to lose your wife's affection.'

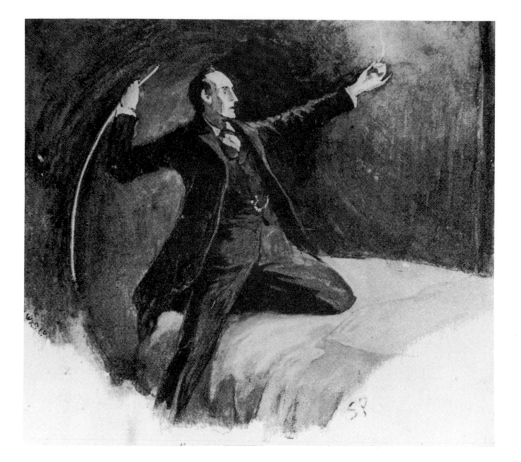

From 'The Adventure of
the Speckled Band'
The Strand Magazine
February 1892

 OW SHALL I EVER FORGET that dreadful vigil? I could not hear a sound, nor even the drawing of a breath, and yet I knew that my companion sat open-eyed, within a few feet of me, in the same state of nervous tension in which I was myself . . . Twelve struck, and one, and two, and three, and still we sat waiting silently.

Suddenly there was the momentary gleam of light up in the direction of the ventilator, which vanished immediately, but was succeeded by a strong smell of burning oil and heated metal. Someone in the next room had lit a dark lantern. I heard a gentle sound of movement, and then all was silent once more, though the smell grew stronger. For half an hour I sat with straining ears. Then suddenly another sound became audible – a very gentle, soothing sound, like that of a small jet of steam escaping continually from a kettle. The instant that we heard it, Holmes sprang from the bed, struck a match, and lashed furiously with his cane at the bell-pull.

'You see it, Watson?' he yelled. 'You see it?'

But I saw nothing. At the moment when Holmes struck the light I heard a low, clear whistle, but the sudden glare flashing into my weary eyes made it impossible for me to tell what it was at which my friend lashed so savagely. I could, however, see that his face was deadly pale, and filled with horror. . . .

He had ceased to strike, and was gazing up at the ventilator, when suddenly there broke from the silence of the night the most horrible cry to which I have ever listened. It swelled up louder and louder, a hoarse yell of pain and fear and anger all mingled in the one dreadful shriek. They say that away down in the village, and even in the distant parsonage, that cry raised the sleepers from their beds. It struck cold to our hearts.

From 'The Adventure of the Reigate Squire'.
The Strand Magazine
December 1891

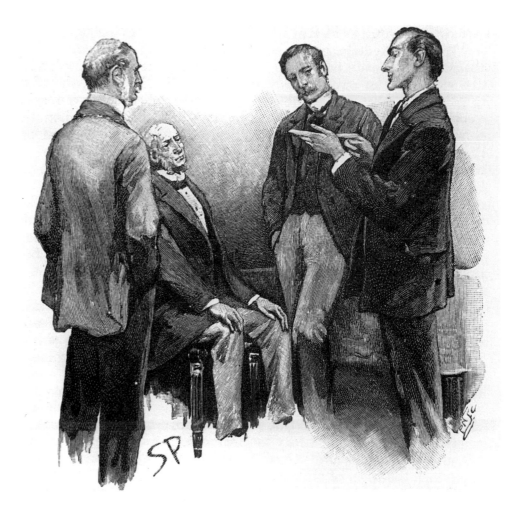

 ' WISHED MR ACTON TO BE PRESENT while I demonstrated this small matter to you,' said Holmes, 'for it is natural that he should take a keen interest in the details. I am afraid, my dear Colonel, that you must regret the hour that you took in such a stormy petrel as I am.'

'On the contrary,' answered the Colonel, warmly, 'I consider it the greatest privilege to have been permitted to study your methods of working. I confess that they quite surpass my expectations, and that I am utterly unable to account for your result. I have not yet seen the vestige of a clue.'

'I am afraid that my explanation may disillusionise you, but it has always been my habit to hide none of my methods, either from my friend Watson or from anyone who might take an intelligent interest in them. But first, as I am rather shaken by the knocking about which I had in the dressing-room, I think that I shall help myself to a dash of your brandy, Colonel. My strength has been rather tried of late.'

'I trust you had no more of those nervous attacks.'

Sherlock Holmes laughed heartily. 'We will come to that in its turn,' he said. 'I will lay an account of the case before you in its due order, showing you the various points which guided me in my decision. Pray interrupt me if there is any inference which is not perfectly clear to you . . . Now, in this case there was not the slightest doubt in my mind from the first that the key of the whole matter must be looked for in the scrap of paper in the dead man's hand.'

From 'The Adventure
of Silver Blaze'
The Strand Magazine
December 1892

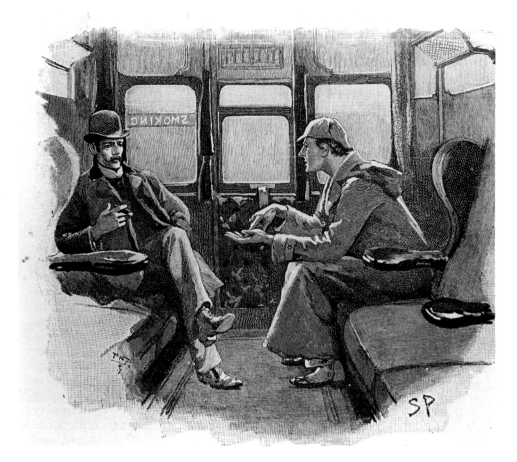

'E ARE GOING WELL,' said he, looking out of the window, and glancing at his watch. 'Our rate at present is fifty-three and a half miles an hour.'

'I have not observed the quarter-mile posts,' said I.

'Nor have I. But the telegraph posts upon this line are sixty yards apart, and the calculation is a simple one. I presume that you have already looked into this matter of the murder of John Straker and the disappearance of Silver Blaze?'

'I gave seen what the *Telegraph* and the *Chronicle* have to say.'

'It is one of those cases where the art of the reasoner should be used rather for the sifting of details than for the acquiring of fresh evidence. The tragedy has been so uncommon, so complete, and of such personal importance to so many people that we are suffering from a plethora of surmise, conjecture, and hypothesis. The difficulty is to detach the framework of fact – of absolute, undeniable fact – from the embellishments of theorists and reporters . . . On Tuesday evening I received telegrams, both from Colonel Ross, the owner of the horse, and from Inspector Gregory, who is looking after the case, inviting my co-operation.'

'You have formed a theory then?'

'At least I have got a grip of the essential facts of the case. I shall enumerate them to you, for nothing clears up a case so much as stating it to another person.'

I lay back against the cushions, puffing at my cigar, while Holmes, leaning forward, with his long thin forefinger checking off the points upon the palm of his left hand, gave me a sketch of the events which had led to our journey.

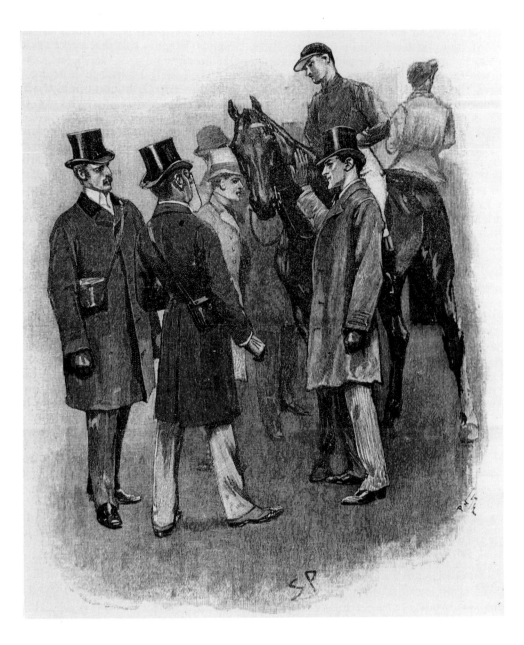

Y DEAR SIR, YOU HAVE DONE WONDERS. The horse looks very fit and well. It never went better in its life. I owe you a thousand apologies for having doubted your ability. You have done me a great service by recovering my horse. You would do me a greater still if you could lay your hands on the murderer of John Straker.'

'I have done so,' said Holmes, quietly.

The Colonel and I stared at him in amazement. 'You have got him! Where is he, then?

'He is here . . . The murderer is standing immediately behind you!'

He stepped past and laid his hand upon the glossy neck of the thoroughbred.

'The horse!' cried both the Colonel and myself.

'Yes, the horse. And it may lessen his guilt if I say that it was done in self-defence, and that John Straker was a man who was entirely unworthy of your confidence. But there goes the bell; and as I stand to win a little on this next race, I shall defer a more lengthy explanation until a more fitting time.'

From 'The Adventure of
the Final Problem'
The Strand Magazine
November 1893

E ROSE AND LOOKED AT ME IN SILENCE, shaking his head sadly, 'Well, well,' said he at last, 'It seems a pity, but I have done what I could . . . It has been a duel between you and me, Mr Holmes. You hope to place me in the dock . . . If you are clever enough to bring destruction upon me, rest assured that I shall do as much to you.'

'"You have paid me several compliments, Mr Moriarty," said I. "Let me pay you one in return when I say that if I were assured of the former eventuality I would, in the interests of the public, cheerfully accept the latter."

'"I can promise you the one but not the other," he snarled, and so turned his rounded back upon me and went peering and blinking out of the room.'

'That was my singular interview of Professor Moriarty. I confess that it left an unpleasant effect upon my mind. His soft, precise fashion of speech leaves a conviction of sincerity which a mere bully could not produce. Of course, you will say: "Why not take police precautions against him?" The reason is that I am well convinced that it is from his agents the blow would fall. I have the best of proofs that it would be so.'

'You have already been assaulted?'

110

From 'The Adventure of
the Final problem'
The Strand Magazine
November 1893

'My dear Watson, Professor Moriarty is not a man who lets the grass grow under his feet. I went out about midday to transact some business in Oxford Street. As I passed the corner which leads from Bentinck Street on to the Welbeck Street crossing a two-horse van furiously driven whizzed round and was on me like a flash. I sprang for the footpath and saved myself by the fraction of a second. The van dashed round by Marylebone Lane and was gone in an instant. I kept to the pavement after that, Watson, but as I walked down Vere Street a brick came down from the roof of one of the houses, and was shattered to fragments at my feet.'

 OWARDS THE END OF THE CENTURY a few individualists, inspired by the manifold talents of William Morris, broke away from what was becoming the treadmill of Victorian mass-production to set up small and personal enterprises in self-expression. This occurred to some extent in book printing, binding and illustration, and most notably amongst a small group of artist potters, several of whom had learnt their craft from the larger commercial concerns such as Minton, Doulton and Pilkington. Amongst these were the Martin Brothers. The eldest, Wallace Martin, had been trained at the Lambeth School of Art, and he set up in 1873 a workshop in the Kings Road, Fulham, with two younger brothers who had worked for Doulton. Another brother sold their wares at a shop in Holborn.

Martinware achieved a certain popularity with grotesque birds that had outsize beaks, and caricatured human heads with leering expressions. They seem to have been the special invention of Wallace Martin. I personally find them unappealing. At the same time, however, the brothers designed jugs, dishes and bowls having a distinct oriental influence, with relief and incised decorations in blue, grey, brown and green, depicting floral forms, fishes and

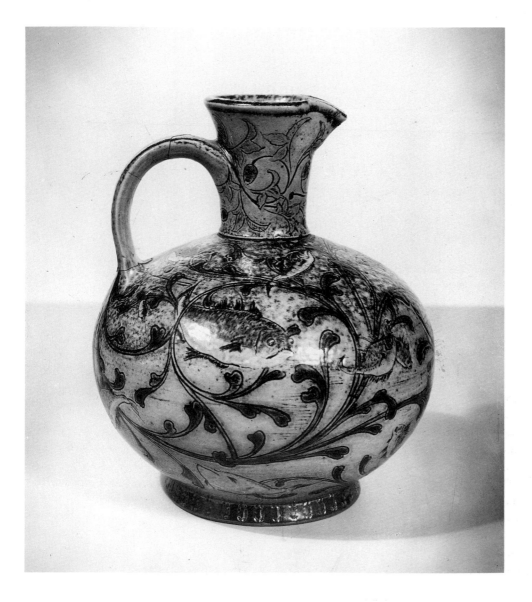

112

A Martinware Jug, greyish brown with dark seaweed and brown fish, 205mm high. November 1886. *Collection, Miss Priscilla Greville*

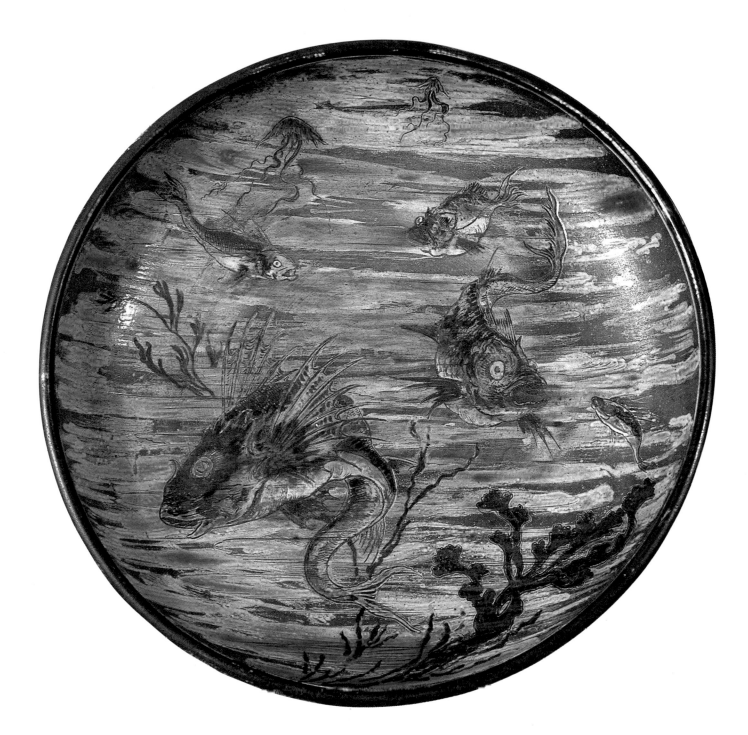

A deep Martinware Dish of curved profile decorated in blue and brown. 1895. 260mm in diameter.
Private Collection

marine plants, At first the firing was done at the Fulham Pottery, then they moved to Southall. Walter Martin was chiefly responsible for the throwing, glazing and firing, and Edwin for the decoration. They worked together in a single workshop, very much as a team, and much of their work is marked with a date on the base. Three of the brothers died between 1910 and 1914. Walter lived on until 1923. Their earliest work is, in my opinion, the best, and was often based on vegetable forms like gourds and marrows.

From the eighteenth century there had always been a certain oriental influence in the more sophisticated English pottery, and the Martin Brothers developed this in a robust and very English form.

Two more Martin jugs are illustrated in the Introduction on page 14.

113

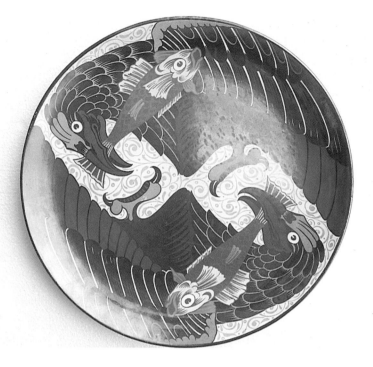

A William de Morgan dish decorated by Charles Passenger with eagle and fish motifs in two tints of red with fronds in buff. Diameter 370mm. Fulham period. *Collection, Edmund Penning-Rowsell*

ILLIAM DE MORGAN was the most distinctive and inventive of the artist potters in the last years of the nineteenth century. He had been a pupil at the Royal Academy Schools, and was persuaded by William Morris to take up pottery instead of painting and stained glass. Like Morris, he was a man of diverse talents, who published two treatises on the craft of pottery and at the age of sixty-seven embarked quite casually on the writing of novels, one of which, *Joseph Vance* (1906) proved, to De Morgan's astonishment, a great success.

In 1864 he had started to make tiles and dishes, inspired to some extent by designs on Persian pottery, and decorated with birds, flowers and fishes, often in a ruby red lustre on a cream earthenware. His bold and emphatic designs, especially those on tiles, had a striking richness of imagery. Some highly talented artists worked for him, including the brothers Fred and Charles Passenger, Joe Juster and Jim Hersey. His first kiln was in Cheyne Row, Chelsea, where he was a near neighbour to Burne-Jones. In 1888 he went into partnership with an architect, Halsey Ricardo, and moved to Merton Abbey in Surrey, but in 1889 his stock and staff were moved back to Sands End in Fulham, which remained the headquarters of the pottery for ten years. During this period De Morgan was resourceful in his treatment of animal, bird and fish motifs. He also became a founder member of the Arts and Crafts Exhibition Society. He earned much praise for a paper he read to the Society of Arts on the history and technique of lustre ware, but in 1892 he was living in Florence, where he had gone for his health. He was constantly worried about the possibility of contracting tuberculosis, which affected other members of his family; but what he had assumed to be in his case tuberculosis of the spine eventually turned out to be no more than a strain. However, he continued to spend his winters in Florence, organising the work of the pottery by correspondence. In his later years, before he abandoned pottery in 1907, he turned

from the increasingly abstract treatment of leaves, flowers, fruit, fishes and birds, and attempted more realistic figurative designs of classical figures, putti, Greek gods and centaurs, decorated by an Italian artist and fired in the Cantagalli factory in Florence. After he had returned to Chelsea in 1910 he remarked to a friend that 'the tiles and pots had vanished like a dream . . . I have turned turtle and am afloat of a sea of Literature'.

An exhaustive and well-illustrated book on the life and work of William de Morgan, by William Gaunt and M.D.E. Clayton-Stamm, was published in 1971 by Studio Vista.

115

A well-head, decorated with William de Morgan tiles collected by the late Edwin Smith. *In Mrs Edwin Smith's garden, Saffron Walden. Photograph by Julia Hedgecoe*

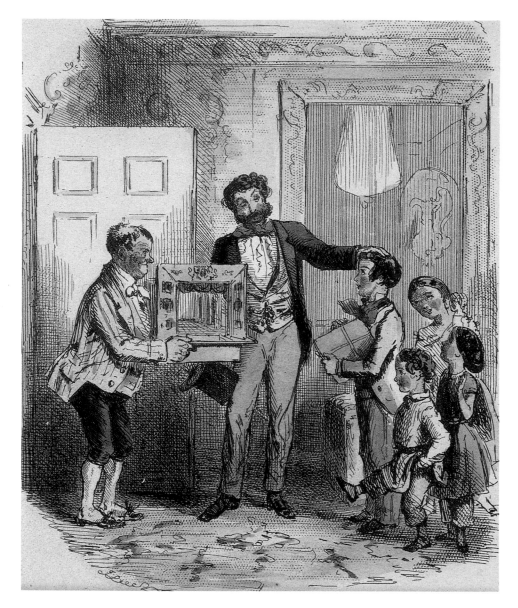

'Here Captain Clarence arrives with the Theatre Royal Drury Lane in miniature and *The Miller and his Men* in a forward state of preparation'. Hand-coloured etching by John Leech in *Young Troublesome, or Master Jacky's Holidays*, 1845

HE FIRST TOY THEATRES seem to have grown out of the vogue in the last years of the eighteenth century for popular coloured prints of well-known actors and actresses of the day in their favourite roles. Robert Dighton, in particular, produced a series of such engravings. Round about 1810 someone had the idea of assembling several such portraits in a single sheet, illustrating characters in a particular play. It was not long before scenery was sold, to match the portraits, together with reproductions of a theatre proscenium and a wooden stage upon which to present the plays. At first the sheets were sold for a penny plain, to be coloured at home by the purchaser, or already hand-coloured for twopence.

By the middle of Victoria's reign some three hundred plays which had been originally produced on the adult stage had been adapted for toy theatre presentation. This was the period of the Romantic Revival, which was reflected in the Toy Theatre with scenes of dungeons in which innocent girls were imprisoned by wicked barons, until they were rescued by gallant sweethearts, whilst Noble Moors and ghostly spectres stalked through ruined castles and

116

abbeys. The 'books' which provided the plots were written for the most part in over-emphatic dialogue which aped the melodramatic style of speech adopted by so many actors of the period. The style of acting was confined to two basic and rather stilted positions. One was in profile, the body turned slightly away from the footlights, one foot thrown forward, one arm raised, sometimes holding a dagger or sword, sometimes pointing an accusing finger. The second position was facing the audience, with feet well apart and both arms flung wide, expressing amazement, rage, grief or exultation, as the situation demanded.

Pantomime, a mixture of ballet and fantasy, incorporating a harlequinade, with Harlequin and Columbine as leading characters, had been entertaining adult audiences throughout the eighteenth century. In the nineteenth century the emphasis of the harlequinade changed, under the inspiration of Grimaldi, so that the Clown became the leading character, and much comic business was introduced. Harlequin and Columbine still provided a graceful ballet, but Harlequin also wielded a magic bat with which he performed tricks of transformation, such as turning a gardener into a wheelbarrow or a sentry box into a file of soldiers. These, too, were featured in every adaptation for the toy theatre.

Originally Pantomime was not especially associated with Christmas, and it was not until the end of Victoria's reign that it became a children's entertainment, based on nursery rhymes, with a Principal Boy and a Dame.

117

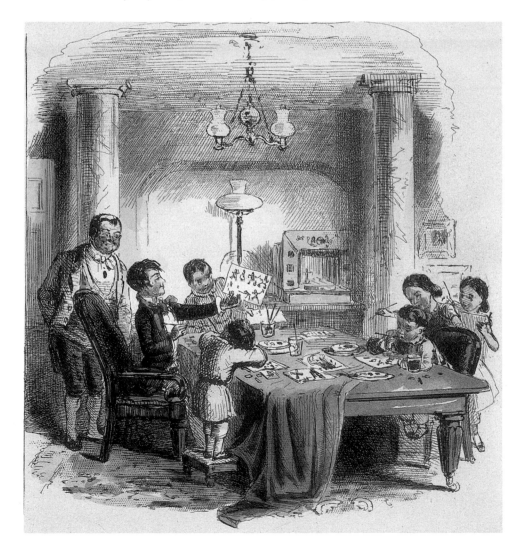

'Further preparation of *The Miller and his Men.'* Hand-coloured etching by John Leech in *Young Troublesome*, 1845

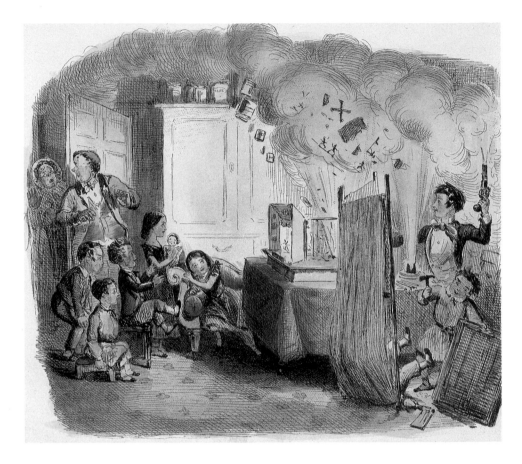

'Grand evening rehearsal of *The Miller and his Men* and terrific explosion in the Housekeeper's room'. Hand-coloured etching by John Leech in *Young Troublesome*, 1845

The earliest printed toy theatre sheets that have survived are dated 1811. The indications are that William West was probably the originator. In 1834, however, J.K. Green, whose name had appeared on some of the first sheets to have survived, proudly announced himself on the covers of his books of words as 'the Original Inventor and Publisher of Juvenile Theatrical Prints, Established 1808'. No evidence for this has survived, but in 1812 he had published some sheets of Harlequins, Columbines and Clowns, and some of the characters in *The Secret Mine* and *Valentine and Orson*. The original artist's sketches for *The Secret Mine* exist in the British Museum. He seems to have been forced out of business by William West, who had set up a circulating library in 1811 in Exeter Street, off the Strand.

William West issued an impressive 'Catalogue of Original Tragic, Fancy, and Comic Characters; as performed at the Theatres Royal' and at a number of other theatres. West also produced little booklets containing saucy songs sung at tavern concerts in such resorts as the Coal Hole. (A pub of that name is still in existence in the Strand.) His last plays, *Olympic Revels* and *The Brigand*, were issued in 1831. He died in 1854, having become a shabby old man and a drunkard, who kept a tame fox as a pet.

During West's lifetime a rival concern called Hodgson and Co. set up in Newgate Street, and produced some excellently designed toy versions of contemporary successes on the adult stage. After Hodgson went out of business in 1830 Martin Skelt bought up some of his copperplates and stock and issued them over his own name. Skelt's plays, of which a favourite was *The Miller and his Men*, were sold not only in London but all over Britain. In Edinburgh in 1860 a boy named Robert Louis Stevenson gazed with wonder at a stationer's window containing Skelt's 'sheets of gesticulating villains, epileptic combats,

118

Webb's Characters in *Harlequin Jack and the Beanstalk*, Plate 5. Published by W. Webb, 146 Old St., St Luke's, 1861

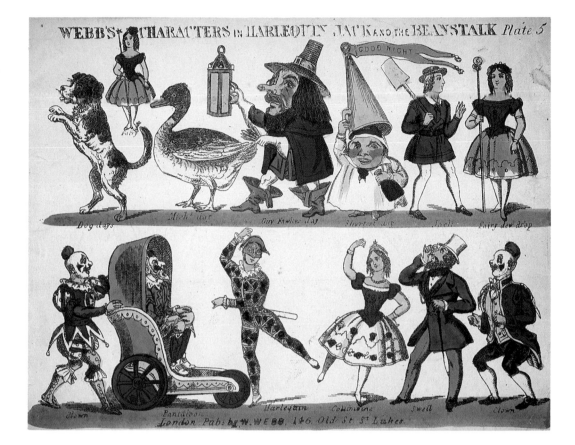

Scene 12. Webb's Scenes in *Harlequin Jack and the Beanstalk*. Published by W. Webb, 1861

Mr Sawford as Black
Ralph.
Published by E. Skelt

bosky forests, palaces and warships. . . .' Some of Skelt's plates were taken over
by W.G. Webb, who continued to publish until the 1880s, and whose son was
selling plays up to the 1930s.

The heyday of the Juvenile Drama, however, was just before the accession
of Queen Victoria. Numerous new publishers cropped up in the eighteen-thirties.
The most popular plays included *The Red Rover, The Flying Dutchman* and
The Maid and the Magpie. During Victoria's reign the Juvenile Drama became
what its name suggested, almost entirely a recreation for children, and the
coloured etchings from Leech's *Young Troublesome*, reproduced here, are no
doubt an accurate representation of its place in mid-Victorian family life.

Benjamin Pollock, whose name has been so closely connected with the Toy
Theatre in modern times, was born in 1856, and took over Green's sheets. He
was a contemporary of Webb and was widely regarded as 'the last of the toy
theatre makers'. His business in Hoxton was later taken over by his daughter
Louisa. As recently as 1944 a bookseller, Alan Keen, who was an enthusiast
for the Toy Theatre, acquired the relics of the business, and Sir Ralph
Richardson and Robert Donat joined the Board of Benjamin Pollock Ltd. In
recent years it has continued as Pollock's Toy Museum, in Scala Street, off
the Tottenham Court Road. Many of the original designs have been revived.

As an art form the toy theatre is remarkable in having hardly changed its
form and artistic conventions for over a hundred and fifty years. The name of
George Cruikshank has been quoted as being responsible for some of the early
designs, as these bear the initials G.C. But these were probably the work of a

120

POLLOCK'S
CHARACTERS & SCENES
IN THE
BATTLE
OF
WATERLOO
12 Plates Characters. 12 Scenes, &c.
2 Plates Wings. No. 18 & 27
Book Price 4ᵈ

Napoleon. *Wellington.*

Engagement between the Life Guards and Cuirassiers. Death of Shaw the Lifeguardsman.
London, Published by B. Pollock, 73, Hoxton Street, Hoxton

Pollock's characters in
The Battle of Waterloo,
originally published by
Green in 1842 and based
on an equestrian drama
at Astley's Amphi-
theatre

professional scene painter named George Childs. It would seem that the artistic conventions of the *genre* – the stiff poses of the figures and the vivid primary colours of their costumes – were developed by the early publishers themselves, one of whom, Arthur Park, was an artist and engraver who also designed valentine cards. W.G. Webb also was a competent artist and drew and engraved his own plays, as well as some for Skelt. In the 'eighties an artist called Tofts enlarged and improved some scenes of *The Sleeping Beauty* for Pollock, creating some delightful magic forests, fairy lakes, princes' palaces and ogre's kitchens. These were the last original designs for the genuine Juvenile Drama.

Jack Yeats, the brother of W.B. Yeats, wrote and designed some toy theatre plays in the early years of the twentieth century, and later Lovat Fraser and Albert Rutherston worked on toy theatre. Later a play, *The High Toby*, was specially written for the toy theatre by J.B. Priestley. But the toy theatre as an institution has never become a sophisticated entertainment, or sought to become 'up-to-date'. The conventions of Webb, Skelt and Pollock still hold the (paper) boards.

The standard book on the subject, George Speaight's *History of the English Toy Theatre*, is now out of print; but its author, to whom I am grateful for the loan of illustrations, still gives 'live' performances on his own toy stage.

OST PEOPLE, if asked, would probably maintain that the cigarette card was an invention of the twentieth century. In fact the first cigarette card was produced as long ago as the mid-1870s in the United States; and during the second half of the nineteenth century nearly five hundred sets were issued.

In the middle of the Victorian period cigarettes were marketed in America, where the majority of cigarettes were manufactured, in packets of five. Some sort of stiffener was required in the form of a plain card to keep the packet rigid and prevent damage to the contents. In the mid-1870s an American manufacturer decided to utilize the advertising value of the stiffener by printing a picture on one side of it. The first subject chosen was a portrait of the Marquis of Lorne, the eldest son of the Duke of Argyll, who happened to be Governor-General of Canada at the time. This was issued, according to references in American journals of 1879, with packets of cigarettes with the Marquis of Lorne as brand name. The original card is reproduced in the middle of this page. It was a single card, not, as far as is known, one of a series, and until recently only one copy was known to have survived.

Other manufacturers quickly saw the marketing advantages of a pictorial card. With the introduction of mechanical colour lithography in 1880 artists of repute were attracted to the production of cards, and before long the backs of the cards were embellished with descriptions written with surprising attention to detail and authenticity. The early cards produced in America were devoted to portraits of beautiful actresses, national flags, scenes of American history, baseball stars, boxers, jockeys and football stars. One of the partners of the firm of Allen & Ginter had been a former Confederate officer and he produced a series of pictures of beautiful girls he employed (naturally from old Southern families).

The tobacco moguls quickly saw the advertising value of the cards, and there was great competition between them. The American market seems to have been dominated by a tycoon called James Buchanan Duke.

Soon the idea was taken up by British manufacturers and the first series of advertising cards was issued by W.D. & H.O. Wills in 1888.

Having virtually established a monopoly of the cigarette market in America James Buchanan Duke bought the firm of Ogden of Liverpool for five and a half million pounds and began to wage commercial war with cigarette cards on the other established British firms. Thirteen of the principal British firms joined forces to form the Imperial Tobacco Company in 1901. James B. Duke and Sir William Wills faced one another across the commercial battlefield. Not only did Duke issue cards, but he offered to buy back sets for cash, and thus anticipated the sales coupon by nearly half a century. His cards were then given in albums to hospitals to entertain their patients.

In 1902, however, Duke and Sir William made a truce. Duke sold Ogdens to the Imperial Tobacco Company for fifteen million dollars and the I.T.C. agreed to restrict its trade to Britain and the Channel Islands. A new company, called the British American Tobacco Company was formed, with Sir William Wills, James Duke and members of the Ogden family, C.E. Lambert and W.G. Player on the Board, to exploit the export business.

The series illustrated here were all issued during the reign of Queen Victoria, the last of them celebrating the Boer War. One of the earliest was devoted to an outstanding example of native American art, John James Audubon's *Birds of America*, painted between 1827 and 1838. It established one of the traditions of the cigarette card, namely a high standard of artistic integrity and factual

The illustration above is of the earliest card which is known to have been issued with cigarettes. It depicts the Marquis of Lorne. Until recently only one copy of this card, in the Metropolitan Museum, New York, was believed to have survived. A second copy, however, has come to light, and is in the collection of Mr E.C. Wharton-Tigar, by whose kind permission it is reproduced here for the first time. The owner has arranged to bequeath it, with the rest of his notable collection, to the British Museum

Audubon's Birds
A very rare series
of fifty cards
issued only by
Franklyn Davey
& Co. of Bristol
in 1896

Top row, left: three of a series of ten *Beauties* issued in 1897 by Robinson & Son of Stockport

Middle row, left: Ellen Terry in *Faust*, Irving as Mephistopheles, and Sarah Bernhardt as La Tosca, in a series of twenty-five *Actors and Actresses* issued by John Player in 1898

Bottom row, left: Three scenes from a set of twenty cards, *Boer War*, issued in 1900 by B. Morris & Sons Ltd. All the officers and men illustrated were awarded the Victoria Cross

Top row right:
Three of a set of
World Smokers
issued by Allen
& Ginter in 1888
in the U.S.A.

Middle row,
right: three of a
series of twenty-
five *Star Girls* of
which those here
shown were
issued with Tipsy
Loo cigarettes by
H.C. Lloyd &
Sons in 1899

Bottom row,
right: three of the
Cricketers series
of fifty cards
issued in 1896 by
W.D. & H.O.
Wills

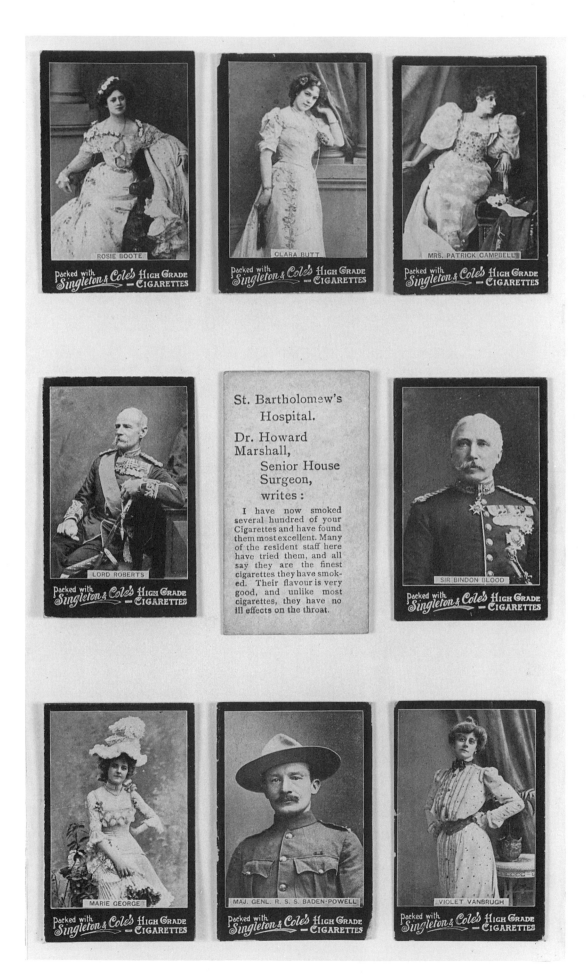

All the cards illustrated on this page except the middle one are from a series of *Celebrities* of the Boer War period issued by Singleton & Cole in 1901. The central illustration is of the back of a series issued by Drapkin & Milhoff in 1901

accuracy. There were also, of course, subjects of more popular appeal to the masses, such as the series of Cricketers issued by Wills in 1896, Actors and Actresses issued by Player in 1898, and the Tipsy Loo girls issued by Lloyd in 1899, which recapture delightfully the vulgarity of the British music hall and the burlesque theatre of America.

All these early sets are now extremely scarce and command high prices, though the rarest and most expensive set is Taddy's Clowns, which was produced around 1920 but was never actually issued, as the firm of Taddy & Co. closed down because of a strike.

The author is grateful to Mr Peter Scully, a member of the Council of the Cartophilic Society, and contributor of a history of the subject to *The Saturday Book*, for his guidance and advice. The author is also most grateful to Mr Wharton-Tigar for allowing his great rarity to be reproduced. All the other cards reproduced are in Mr Scully's collection.

It is unfortunate that one of the best informed books on cigarette cards, *Cigarette Cards and How to Collect Them*, by I.O. Evans, published in 1937, has been out of print for sometime and is now difficult to find except in public libraries. But another well-informed book, Dorothy Bagnall's *Collecting Cigarette Cards and other Trade Cards* (1965) can be found in a paperback edition.

INDEX OF ARTISTS AND CRAFTSMEN